The MURDER of
JoANN DEWEY
in
VANCOUVER,
WASHINGTON

Pat Jollota

THE
History
PRESS

Published by The History Press
Charleston, SC
www.historypress.com

First published 2018

Manufactured in the United States

ISBN 9781467138857

Library of Congress Control Number: 2018945799

This effort is dedicated to all of those who "liked" the "Growing Up in Vancouver" Facebook page.

CONTENTS

ACKNOWLEDGEMENTS

There are so many people to acknowledge, and some may have forgotten that they helped—it has been such a long time brewing! While I was the curator in the Clark County Historical Museum, I would spend the slow times reading the bound editions of old newspapers. That's where I first came upon this complicated and somewhat bizarre story. This story fascinated me because I couldn't figure out how they identified the killers—and then how in the world they convicted them.

As I talked to people about it, I became aware of the division of opinion in the community. Those who adamantly believed in the Wilson brothers' guilt were matched by those equally sure of their innocence. This was decades after the crime. Those conversations inspired people to pass on information about the murder and trial. For that sharing, I am grateful and indebted.

Thanks to Lieutenant Douglas Luse of the Vancouver Police Department, who generously shared his grandfather's investigator's notebook. That made sense of the headlines and made them easier to understand. Doug also accompanied me to an interview and conversation with retired Lieutenant William Farrell that opened some new windows into the case. Vancouver detective Howard Anderson gave me a scrapbook that consisted of every newspaper article from all of the local papers about the crime, trial and aftermath.

Clark County assistant prosecutor Kim Farr, now retired, dug into his collection of vintage detective magazines and gave me an issue published in June 1950 that laid out the steps that led to the suspects' arrest.

Superior Court judge John Wulle passed on a copy of the Supreme Court findings on the Wilson appeal.

Washington State Patrol chief John Batiste and his assistant, Bridget Hamilton, shared photographs and encouragement.

The late historian Richard Grafton collected photographs and compiled a book on the history of the Vancouver Police Department that was a great help in background information. His widow, Sandra Grafton, passed on his research.

Linda Lutes, the photo archivist with the *Columbian* newspaper, is a wizard at finding photos.

Lieutenant Kim Kapp is the keeper of Vancouver police history. Paula Person, volunteer with the Vancouver Police Historical Committee, always came through.

Clark County sheriff Chuck Atkins and Deputy Fred Nieman offered more data and photographs.

My friends at the Clark County Genealogical Society were there with even more data.

Emilou Jones Nelson graciously shared family stories and photographs that were greatly appreciated.

Arlo Peterson, thank you for your kind words and your helpful suggestions that made sense of a complicated story.

John Gentry, retired, from the Vancouver Fire Department, for adding wonderful insights and advice.

Superior Court judge Suzan Clark filled in those spots of legal procedures and terms that I was hazy on in a most delightful way.

I don't think I could have written any book without the over-the-top assistance from the staff at the Fort Vancouver Regional Library.

INTRODUCTION

The tragedy of JoAnn Dewey rocked the city of Vancouver and Clark County, Washington. The shockwaves rippled into Portland, Oregon.

Vancouver is a Washington city separated from Portland, Oregon, by the Columbia River. In 1950, there was only one bridge, the Interstate, which connected the two cities. On the north end of the bridge is downtown Vancouver, Washington. On the south side of the bridge then was an amusement park, Jantzen Beach. Nearby stood a racetrack, Portland Meadows. To the west of that structure were the ruins of the city of Vanport, destroyed by a flood two years prior in 1948.

There had always been crime, of course, and some murders, but those crimes were explainable—the motives clear. This murder was inexplicable: a young woman beaten and carried away—with upstanding citizens watching! The populations of both cities were swept up into the story.

The search for the missing girl gripped the cities. Every clue, every report, every rumor was absorbed and passed on. When the battered and disfigured body was found, the news swept across the county. Hypotheses, gossip and rumors proliferated.

Into that atmosphere came the news of the arrest of two young brothers. They never stopped protesting their innocence. Every day, the newspapers covered the crime, the arrest and the subsequent trial on front pages. This was an unprecedented event after all. This was the kind of crime that only happened in big cities.

As the story evolved, it became ever more complicated. Side stories developed, and conjecture accompanied them. Scandals shocked the soul. Conspiracies were discussed. Gradually, the community began to split. Many people were convinced of the brothers' guilt. Others were sure that they were innocent and being framed. The arguments continued for months in the barbershops, Grange Halls and church socials.

Part of the puzzle was the speed with which the men were identified, located and arrested. They were young. They were publicly charming and well groomed. They became local celebrities. Most of the confusion that ensued was caused by lack of experience and a surplus of bravado at top echelons. Politics entered into it; personalities complicated it. All of these conditions resulted in a community divided. The divide continues. That should never have happened.

The story became overwhelming. The front-page dominance of the daily drama continued for months across the region and beyond. As the years have passed, the story has changed. It became a cautionary tale, one that parents would tell their daughters: "The streets are dangerous, even in a small town—you must be cautious and stay with the group." For others, it became the basis for tales of corruption and injustice—always a mystery. The story altered with the retelling as new elements were grafted onto it. New theories were put forward.

JoAnn Dewey should have grown up, gotten married, had children and baked cookies for grandchildren. Whatever the outcome of the unfinished story of JoAnn's life, she was cheated out of it—never to turn twenty-one, never to vote, a lifetime of laughter and tears stolen from her. She was cheated. Her family was cheated. Murder has a way of rippling out far beyond the victim and the murderer. It echoes over generations.

Almost everyone drawn into this case saved memories of it. This book is drawn from those saved memories.

THE DEWEY FAMILY

JoAnn Louise Dewey was a pretty eighteen-year-old girl growing toward beauty. Round-cheeked, with a cap of dark-brown curls framing her face, she had the dewy complexion with which many women in the moist Northwest are blessed. Strong brows framed flashing dark eyes. She had a crescent-shaped scar near her mouth that looked like a dimple. She was not tall but was strongly built, with broad shoulders; her baby fat was melting away. She was going to be stunning.

JoAnn had been born into a large and deeply religious family in Meadow Glade, Washington. Meadow Glade was a charming little enclave near Battle Ground that had been founded by Seventh-day Adventists, and the Dewey family was an active part of that community. JoAnn had four brothers: James, Burton, Clyde and Ivan Dale. Her sisters were Lila and Gladys. All had attended school at the Columbia Adventist Academy. Her parents, Noble Clyde and Anna, were country people, plainspoken and hardworking. Anna worked in the Battle Ground Nursing Home and Clyde at the Bonneville Power Administration. They had converted to the faith and dedicated time to their church. Their house was set back from the road. It resounded with the laughter and bantering of a large family. On a Saturday morning, starched and pressed, the family would fill a row in the church.

As JoAnn began to mature, she attracted the attention of a deacon of the church, Donald Strawn. He was a married man, but he convinced the sixteen-year-old of his true and undying love. Their affair grew more intimate, and he bought her gifts: a raincoat that she liked and an *Evening*

in Paris set on Christmas. He promised that when she was old enough, he would divorce his wife and they would be together always.

Donald Strawn had served in the navy during the Pacific Campaign of World War II. His ship had been torpedoed, and he was often in pain from the injuries that he'd sustained then. Later in life, he would undergo surgeries to repair his back and legs, but he was young in 1950. A marriage to Noralee Jones had produced children, perhaps too fast for him. In April 1949, he and his wife had filed divorce papers. They reconciled, and the suit was withdrawn.

JoAnn Dewey was just eighteen years old when she disappeared on a damp, chilly April night in 1950. *Author's collection.*

More mature women than JoAnn had believed similar protestations of love. Sure enough, when the time came, there was to be no divorce, no marriage, no happily ever after. He told JoAnn that he'd had a vasectomy and there would be no children should they marry. He added that he didn't like children. JoAnn wavered. She loved Strawn, she would tell her friends, but a marriage without children? That would not be for her.

The deacon and his wife tried to repair their marriage, and JoAnn tried to rebuild her life. Studies since have shown that abused girls often turn to inappropriate sexual behaviors as a result. JoAnn was no different; she fell in love too easily and too often. That would be used against her after her death—that's the way it was in 1950, and it would be said that maybe she had brought her fate on herself by being out late and alone on a lonely and deserted side street and by not being a virgin.

Feeling shamed and humiliated, JoAnn fled Meadow Glade, but not far. She would not—indeed, could not—leave her close-knit family, especially her brother Ivan. They had always been close. He was her confidant and protector. Another deacon in the church found a position for her at the Portland Adventist Sanatorium, at Sixth-Ninth Avenue Southeast and Southeast Belmont Street in Portland, in the Mount Tabor neighborhood. She moved in with Opal Lewis, another young girl from the tight-knit community of Meadow Glade. Portland was not far, but far enough away to start anew. Life in the big city was very different

A page from the Columbia Academy Yearbook shows an eighth-grade JoAnn at the lower left. Joan Crawford, the last of her friends to see her alive, is the second from the left in the top row. *Randall Family Collection.*

from Clark County. Still, Meadow Glade was just a Greyhound bus ride away. She missed her family. She would go home whenever she could. She was just eighteen.

She and her friend Joan Crawford had been close since their school days in Meadow Glade. They had attended the Columbia Academy together. Now twenty, Joan had been married and divorced. She lived in an apartment over a restaurant on Burnside in Portland. JoAnn's brother-in-law worked in that restaurant. Joan and JoAnn explored the city together and occasionally double-dated.

On Sunday night, March 19, 1950, at seven o'clock, JoAnn ate dinner at the Sanitarium. She had a meat substitute—the Sanitarium was the only place in Portland that served that dish. She met Joan, and the two girls went to a movie, *Samson and Delilah*, at the Paramount Theater.

The evening was chilly, as is typical of a Pacific Northwest early spring. There was a mist of intermittent rain. It was the damp cold that clings to your skin. After the movie, Joan and JoAnn walked to the bus depot at Fifth and Salmon, where JoAnn bought her ticket to Meadow Glade. The bus would leave in twenty minutes. She walked with Joan to her local bus stop on the corner. JoAnn wore a light-blue skirt; a white peasant blouse with a ruffled neckline; and a long, lightweight coat the color of rust. Her outfit was loose; she hadn't put on the matching belt. She had pinned her hair back with a pair of silver barrettes.

The friends waved goodbye to each other. Joan got on her bus, and JoAnn returned to the Greyhound station. Joan said later, "It was the last time I saw her alive."

Arriving in Vancouver, JoAnn found that she had missed her bus. There was nothing to be done about it. The ticket agent was later to testify that she was quite upset; she even stamped her foot. It was of no use. The Greyhound bus had already started its trip from Vancouver to Meadow Glade, and there would not be another for hours. She used the pay telephone at the depot to call a friend in Meadow Glade, Fred Strawn. He had been asleep and was still drowsy. He told her that if she couldn't get anyone else to pick her up he'd do it. He went back to bed and back to sleep.

JoAnn next called her mother, begging for a ride home. Her mother had to work that night at her job at the Battle Ground Nursing Home. JoAnn decided to walk to St. Joseph's Hospital on East Twelfth Street. A neighbor, Delia Crull, was a night nurse there and would bring her home the next day. She could sleep in the nurse's dormitory.

JoAnn began the short, fifteen-minute walk from the Stage Depot at Fifth and Main Street in downtown Vancouver to the hospital at Twelfth and E Street. The sound of her heels echoed in the deserted streets. Just a few years earlier, those streets would have been bustling even late in the evening. Vancouver had been a sleepy little riverfront town when World War II erupted. The Kaiser Shipbuilding Company built a shipyard on the riverfront and tens of thousands of workers had arrived. Dozens of new businesses, restaurants and bars had opened downtown. Vancouver Barracks, the army base in the heart of town, had been filled to capacity. Alcoa Aluminum Company just downriver worked twenty-four hours a day. By March 1950, however, all of that was over. The war ended and the shipyards were closed—just a handful of personnel lived on the barracks. Alcoa Aluminum had cut back to an eight-hour day. Empty storefronts dotted downtown. Many of those temporary workers had settled into Vancouver as it returned to being a quiet small town, but many more had moved on. Just two years earlier, the Memorial Day Vanport Flood had destroyed that small town between Vancouver and Portland. Many residents of that wartime city had relocated into Vancouver. On New Year's Eve 1950, fourteen thousand residents of McLoughlin Heights became citizens of Vancouver as that wartime neighborhood was annexed into the city. But off Main Street, the sidewalks were dim, with few streetlights.

JoAnn's destination, St. Joseph's Hospital, was an imposing five-story building of patterned red brick. Large bow windows projected from the side

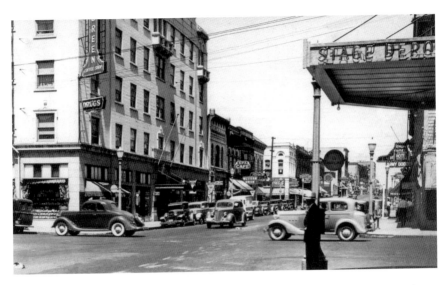

Fifth and Main Streets in downtown Vancouver, Washington. JoAnn left the bus depot here to walk to St. Joseph's Hospital. *Author's collection.*

walls. To the east was a small building, also brick, containing the nurses' dormitory. The Sisters of Providence had built the hospital, and across the street stood the Providence Academy complex. There was a large well house, a laundry building and the academy itself. The academy still stands as an 1873 orphanage and Catholic school designed and built by Mother Joseph of the Sacred Heart. To the west lay a small courtyard group of apartments called Central Court Apartments, also red brick, with a trim of shiny white. It was an upscale residence. Several doctors lived in the complex, as did a veterinarian, a state legislator, a county commissioner and a chief deputy for Clark County Sheriff's Department. There would be little traffic on the street. Twelfth Street ended at the Military Reserve at G Street. Beyond G Street was a vast meadow, artillery ranges, bivouacs and cantonments.

JoAnn was not afraid. Vancouver was a safe town. Had she known of an incident just a week earlier, she might have taken more care. At Thirteenth Street and Broadway, just a few blocks west of the hospital, a young woman had been badly beaten by two men who sprang out of a dark sedan. She fought them off, escaped and ran to a pair of men one block away. She asked them to call police. Tell them, she said, that those men had tried to drag her into their car. The men drove quickly to the Washington State Patrol office and told the story. They described the young woman: dark hair, wearing a white coat. The trooper called

15

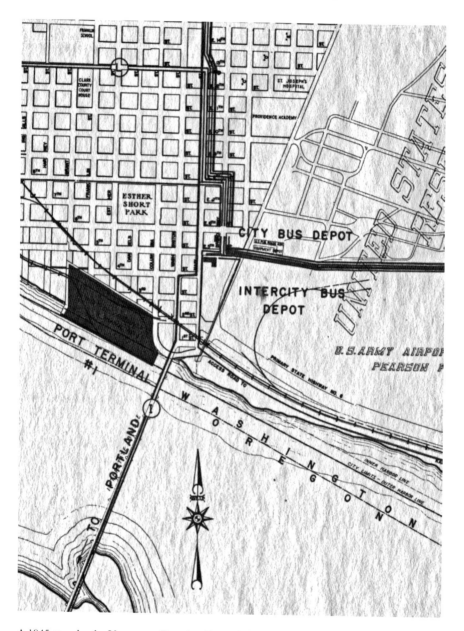

A 1945 map by the Vancouver Planning Commission. The bus would have come across the bridge from Oregon, headed north. At the Interstate Bus Terminal, at about the center of the map, JoAnn should have changed to the Greyhound headed north to Maple Grove. Instead, she walked north seven blocks and then east. St. Joseph's Hospital is just north of Providence Academy. To the east is the U.S. Army Vancouver Barracks. *Author's collection.*

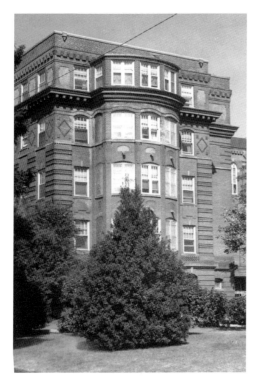

St. Joseph's Hospital has since been razed, but on that night in 1950, warm lights would have glowed from the bowed windows. *Author's collection.*

Vancouver Police Department. A search was made, but neither the woman in the white coat nor the dark car was ever found. JoAnn had not heard of that, and the story had received little notice.

On Twelfth Street, near the hospital and outside the Central Court Apartments, a dark four-door sedan was parked. Inside sat two men, drinking beer. They waited. JoAnn turned to her right onto Twelfth Street. The warm and welcoming lighted windows of the five-story St. Joseph's Hospital shined straight ahead.

THE WILSONS

The Wilson family was a large one, as was the Dewey family, but there the resemblance ended. The Wilsons were constantly on the move, crowded apartment to tumbledown house, state to state, city to city. There were Rassie, Grant, Glenn, Turman and Utah. A sixth brother, the eldest, Lester, had been killed in Sicily during World War II. There were two sisters. They appeared in school unwashed and frequently unfed. Their records at the old Franklin School and later at Hough Elementary showed that they were troublemakers. A teacher at the Hough School in downtown Vancouver remarked to the principal that these boys should always be assigned to male teachers. They were barely controllable when with a man, as long as discipline was strict and rigidly enforced. All of them dropped out of school before high school graduation. All the children were undersized. In news photographs, the Wilson boys seem to be surrounded by giants.

Their father, Mose Ramsey Wilson, was one of seven children born to Grant and Melavina Wilson in Missouri. Mose's father, Grant, described himself as a laborer working odd jobs in the census taken soon after Mose's birth. Mose would describe himself as doing the same work in later census information. Since he had only a fourth-grade education, he had difficulty keeping a job. He worked for only short periods of time across the county.

He spent seven years in the Washington State Penitentiary, from 1933 until 1940, for the rape of a thirteen-year-old girl. He also had a long record of drunken offenses and thefts. But he did finally decide to do the right thing

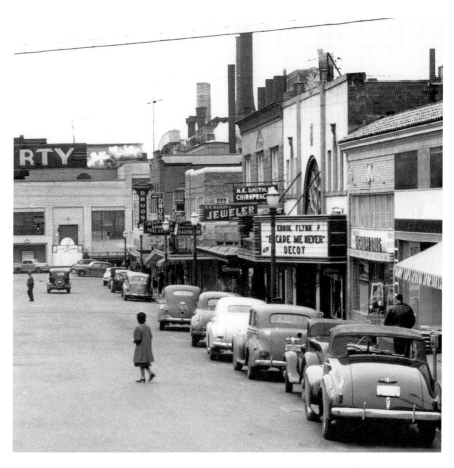

Camas Washington was a mill town when the Wilson family arrived. Fourth Street was the main artery, ending at the huge paper mill that dominated the cityscape. *Author's collection.*

by Eunice. They were legally married in 1946. They moved to a ten-acre farm near Camas, Washington.

In December 1949, Mose was arrested for being drunk and disorderly and resisting arrest. He served six months in the Clark County Jail. His wife, Eunice, had had enough. The marriage was over. Mose moved into a small trailer on Lincoln Street in Silverton, Oregon, forty miles south of Vancouver.

Eunice was a fiercely protective mother, refusing ever to accept that any of her children could transgress. She was deeply religious and was the supervisor of her local Sunday school. She forced the children to go to

Sunday school every week until they each became big enough to refuse to go. She would say, "I raised eight children on the County Welfare because Mose wasn't around much to help."

In the words of her son Grant, "her marriage had never been successful." There was never money. He recalled a Christmas when two of his brothers had brought presents and put them under the tree. He later learned that they had stolen them from someone else's tree.

The eldest brother, Lester, enlisted in the army in World War II and died in combat in Sicily. Eunice sorrowfully hung the Gold Star flag in her window. It would remain in her front window for the rest of her life.

Rassie was the next son. He had scrapes with the law, but he married, had a daughter and found a job at the Kaiser Shipyard.

Glenn, the second eldest, was known as an expert pinball machine burglar. Taverns and restaurants had those machines; he'd break in, hit the machine and be gone in just minutes.

Turman was next. In 1940, at the age of fourteen, he appears in the census as an inmate at the State Training School for Boys at Parcuvia, Washington, in Lewis County. That was his first experience with imprisonment. It would not prepare him for the real thing.

Grant, known only as "Junior" at first, was named for his grandfather. Newspapers referred to him as the "white sheep" of the family, the one who had never been in trouble. As a youngster, he had become attached to a religious family. Under their influence, he became active in the Assemblies of God. He found a job, married and bought a home. He was never arrested for any crime. He was another haven in the storms that beset the family.

Utah was the youngest of the brothers. He, too, would grow up in a reformatory, but in Centralia. The institution in Parcuvia had closed. Following the Wilson family pattern, he was a thief and a burglar.

Patricia, the daughter, was next. When not yet sixteen, she would marry a much older man, Clarence Ostenson, a man in his early forties.

Constance was the second daughter. She avoided the storms of notice that beset the rest of the family.

Names were fluid in the Wilson family. Mose would sometimes be known as "Bill." Eunice could be "Unis" or "Yuena." Grant was just "Junior "for years and then Grant Junior Wilson. He married Hazel under the name J. Grant Wilson, and then he used the name Grant Thurman Wilson. Turman for years used various aliases. He felt that it was harder to track you if you used several names. Before computers, he was exactly right.

The brothers first attracted attention outside the local area in May 1942. On May 4, 1942, two girls, both seventeen, were walking down a sidewalk in St. John's, a suburb of Portland. It was nearly midnight. The moon was just past full. It had been a clear spring day, with a promise of warmer weather for the next day. Three of the Wilson brothers—Turman, then sixteen; Glenn, seventeen; and Rassie, twenty-one—were parked at the curb. At gunpoint, they forced the girls into the car and took them to a wooded area nearby, opposite Linnton, Oregon. Both were beaten and raped by all three men. The weeping girls told police that one of the men, later identified as Turman, wanted to shoot them both lest they identify them later. They were sure of that; they'd seen that he had a gun.

The Wilsons were in a stolen car. They were spotted by Portland police. Rassie punched it. They careened off through the streets of Portland, red lights following behind. The chase ended when they crashed into a pole on Burnside. The police officers were surprised when they came out shooting. The officers ducked for cover, and the trio made their escape. They left a gun behind. When police searched the car, they found an automatic pistol. The officers surmised that the rapists and the car thieves were one and the same, and a description was broadcast.

In Vancouver, rookie officer Edward Mayo read the account in the newspaper. He called Portland and asked for the serial number on the weapon. He then checked local pawnshops and found that it had been pawned and redeemed by Rassie Wilson. This news brought Portland detectives Collie Stoops and Bard Purcell to Vancouver. They met with Mayo at the station. It was obvious that it was time to talk to Rassie Wilson.

Mayo and the two detectives picked up Police Chief Harry Diamond. Harry offered that Rassie would undoubtedly have been with his brothers, Glenn and Turman, both listed as AWOL from the Green Hill School, the formal name of the Washington Boy's Reformatory at Chehalis.

They stopped first at Rassie's home. His wife told them that Rassie was at work, that he'd gotten a job at the Kaiser Shipyard. Chief Diamond knew the captain of the guards there,

Ed Mayo. "Gentleman Ed" matched up the gun that the Wilsons used in their first kidnapping. He was a captain when they returned to Vancouver. He retired as chief. *Vancouver Police Department.*

Henry Wentworth, a retired Washington State Patrol captain. Wentworth quickly located Rassie. At the police station, almost immediately, Rassie broke down and confessed, implicating his two brothers.

Glenn and Turman were picked up at their mother's house in Fern Prairie. They were taken to the Clark County Sheriff's Office, where two more Portland detectives, Eichelberger and Horack, waited. The remaining pair of brothers confessed as Clark County sheriff Robert Brady took it down on a typewriter. He could have written it down, but as Harry Diamond said, "there was nobody faster on a typewriter." The confession came easily; they were excited that it had taken officers in three police cars to arrest them. In addition to the attack on the two girls, they admitted to burglarizing thirty stores and taverns near Vancouver, as well as the robberies of four other women. Rassie's wife was wearing a watch stolen from one of the two teenage victims of the assault. Officers found a suitcase at the property packed with nickels, the proceeds of Glenn's pinball expertise.

All were sentenced to the Oregon State Penitentiary at Salem. Rassie, being the oldest at twenty-one, received the longest sentence: two consecutive twenty-year terms. Glenn, then seventeen, drew a ten-year sentence, and Turman, as the youngest at sixteen, got seven years. Turman learned two lessons: Rassie had confessed and received twenty years; he would never confess. The two girls had identified him; he said that he would never leave a witness alive.

The Oregon State Prison where Turman grew up from the age of seventeen. Two of his brothers, Glenn and Rassie, were still in that institution when JoAnn disappeared. *Author's collection.*

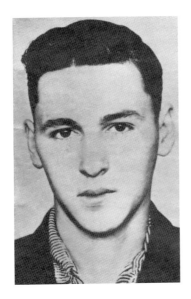

Sixteen-year-old Turman Wilson as he entered the Oregon State Penitentiary after his conviction for kidnapping and rape. *Richard Grafton Collection.*

Turman's mug shots at the time show a good-looking, almost pretty young boy of small stature. His life in prison must have been hell. Glenn and Turman soon made their escape by braiding a rope ladder from towels. They went over the top of the main building and then climbed a ten-foot fence. Rassie by that time was in a tuberculosis ward and was not with them.

Their first objective was to find a car. The pair stole the first car that they came across and vanished into the cold and wet evening. Portland Detective Herman Horack described the brothers as "young but dangerous. They will shoot if they get a gun." They had, he added, admitted to a series of rapes, robberies and car thefts. Officers surrounded the homes of the two Portland girls who were the rape victims—the police said that the Wilsons had threatened to kill them for testifying against them.

Oregon State Police sergeant Francis Sloat received a radio message from the Pendleton police that the stolen car occupied by the brothers had been spotted headed toward La Grande, Oregon. Sloat, along with other officers, was waiting at the entrance to town when the pair roared into town.

The pursuit went down Adams Street and swerved onto Chestnut. Two tires blew out as they careened onto Jefferson from Chestnut. They slammed into a parked car. Glenn jumped from the car and ran through the Union Pacific baggage depot. He escaped the dragnet, but Turman was immediately surrounded and returned to the penitentiary.

Glenn was free for twenty-one days. Clark County chief deputy sheriff Leland Morrow received a tip that Glenn was at his mother's house. A posse of nine men surrounded the house. They spotted Glenn, disguised as an old woman, wearing a long robe and a turban. He jumped out a window and ran into the nearby woods. Although he was a fleet runner, the skirt impeded him. He was captured and returned to prison.

Glenn had a year and a half added to his original sentence for the escape. Eunice Wilson was given a ten-year suspended sentence for harboring a fugitive. Turman, who had stolen the car, had seven years added for the theft

Downtown La Grande, Oregon. Utah and Glenn led police here in a wild pursuit after their escape from the Oregon Penitentiary. *Author's collection.*

and for escape. He was turned down for parole twice but was finally freed on April 19, 1948.

On November 9, 1948, Turman was arrested for armed robbery. That should have brought a sentence of ten years to life. However, Irvin Goodman, his attorney, plea bargained the charge down to grand larceny, so he only served six months in the Portland jail. He was released again on April 1, 1949. He was again arrested in September 1949 after a bungled robbery attempt in which a shot was fired at Kalama town marshal Harry Durgeloh. The constable could not identify his assailant, however, and Turman was released, according to the *Columbian.*

Turman was barely five-foot-six and slender. His forehead was oddly flattened, and his hairline was receding. He had a distinct bald spot, unusual for someone of twenty-seven. His voice was unique and easily recognizable— he spoke in a rapid staccato style—yet he was oddly charming. Young women told him that he looked like the actor George Raft. That pleased him, as Raft often played sophisticated gangsters. Both Utah and Turman were moviegoers, sometimes visiting two theaters in a day.

By October 3, 1949, Turman had found a job in the Pendleton Woolen Mill in Washougal. Those who had hired him were pleased that he was walking a good road to rehabilitation. He had a good attendance record, so the managers were considering him for promotion.

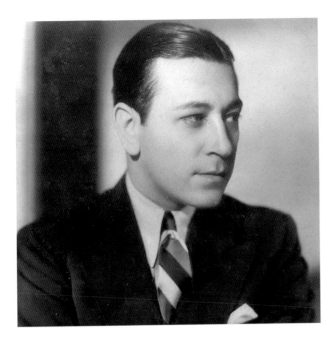

The actor George Raft was known for his portrayals of gangsters and tough guys. Turman had been told he resembled him, so he imitated his style. *Author's collection.*

With closely barbered, tightly curled hair, Utah had the appearance of a forthright young baseball player. By the time he reached eighteen, however, he had a lengthy juvenile record. He had been sentenced to the Training School for boys at Chehalis for auto theft. Following his brothers' example, he also escaped and was also promptly captured and returned.

Shortly after his release, on November 1, 1948, he was picked up on a traffic violation and, under questioning, admitted to more than twelve burglaries, including one at the Rose Grocery and the Cedar Glen Service Station. He was charged with just two burglaries of the dozen, and on November 16, 1948, he entered a guilty plea. He received a two-year sentence. Deputy Tom McKeag had persuaded Judge Eugene Cushing to go easy on Utah. He did, giving Utah a three-year sentence, one to be served in the county jail and two on probation. Frank O'Brian was appointed as his probation officer.

Nineteen-year-old Utah had become smitten with tiny sixteen-year-old Lucille Cline. Lucille was only four-foot-ten and painfully slim. She loved dancing. With her standing beside him, Utah appeared tall.

After Utah was released on September 18, 1949, from the burglary charge, he and Lucille married on November 29, 1949. They moved in with Lucille's mother, Gladys, at 210 East Twelfth Street, just three blocks from St. Joseph's Hospital. He assured Lucille that he was looking for work

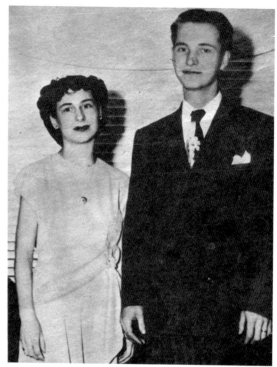

Right: Tiny Lucille Cline stands next to her bridegroom, Utah Galilee Wilson. Their honeymoon would be interrupted by murder. *Author's collection.*

Below: Cletis Luse stands at the far left in this group photo of the Clark County Sheriff's Department. The other men in the photo are not identified. There is a variety of hats and badges displayed, however. *Luse Family Collection.*

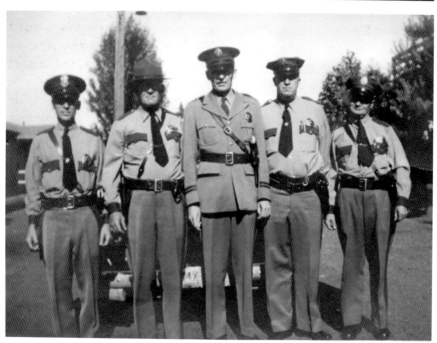

every day, but he was actually fishing. He fished the Washougal River near his mother's home, the Columbia River and the Wind River in nearby Skamania County.

Surprisingly, he developed a friendship with a former neighbor, Cletis Luse, a Clark County deputy sheriff. Cletis listened to Utah; they discussed fishing. When Utah went fishing, he always remembered to bring a fish to Cletis.

On March 14, 1950, Deputy Paul Markley received a call from Utah, asking for Deputy Luse. When he was told that Luse was on a day off, Utah asked if they would like some fresh-caught sturgeon. Utah said that he'd be at the office in a few minutes. Markley said that "two minutes later Utah and his wife walked through the door. He had called from the Janitor's Room across the hall from the office." They discussed fishing the various rivers, especially for sturgeon salmon and steelhead. Markley did not recall, later, if they discussed fishing the Wind River. His report would be entered into Deputy Luse's notebook.

On the evening of March 18, Lucille wanted to go to a dance. Utah wanted to go out with Turman, as Lucille was later to tell Deputy Luse. They argued. Utah became angrier and angrier. At around three o'clock in the afternoon, she said, he slammed his way out of the apartment. She and her mother prepared dinner at the usual time, at 6:30 p.m. Utah had not returned by then, so the two women got dressed up and went to Portland. They came back to find a note from Utah. It was marked 7:00 p.m. and read, "I was here to take you to the dance but you were gone, so I'm going out and have a time for myself, don't know when I will be back."

When he came home, at about 3:00 a.m., he was still angry. Again, according to Lucille's statement, "he did a lot of raving and stomping around, finally going to bed."

On Sunday, March 19, Lucille told Cletis, Utah had the Buick and wanted Lucille to go out with him and Turman. They were going to Silverton to visit their father. She was still angry and told him that her side was aching. He got angry again and left.

Utah called Turman. The two drove away in the dark sedan. Later that night, they stopped on Twelfth Street near St. Joseph's Hospital.

LAW ENFORCEMENT

Harry Diamond had grown up in Vancouver. His father died before he was born. His stepfather, Charles Harvey, was a professional gambler. He taught Harry to gamble, and he became good at it. He joined the army as a cook in order to be able to gamble without interference. He found that gambling was not very lucrative.

At the end of World War I, he found himself back home, stationed at Vancouver Barracks. Harry often claimed that he'd been kicked out of every school in Vancouver except for Central School. Then he would add that was because he'd never attended Central. He had never done anything vicious or destructive, only pranks, but he said it drove his teachers to distraction. He dropped out of school, and from then on, he was self-taught.

In 1934, both of his parents became ill, and Harry went to work for the railroad as a fireman because it paid extra for subsistence. The mayor, Ed Hamilton, knew Harry. He urged him to apply for the police department. He did and was appointed on January 1, 1935.

His reputation as a prankster continued. One afternoon, he noticed some dusty old stuffed birds decorating a bar. The owner was going to redecorate and update the saloon. Harry talked him out of the specimens; Sheriff William Thompson had a farm near Battle Ground. On the farm, he had a small lake where he raised prize-winning trout. He was inordinately proud of those fish. Harry showed up at the farm just after dawn. He planted a bedraggled and moth-eaten stuffed blue heron in the sheriff's lake.

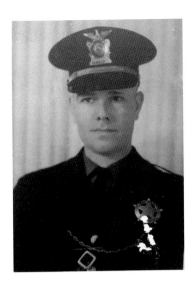

Harry Diamond as a sergeant in the Vancouver Police Department in 1942. *Vancouver Police Department.*

Harry pounded on the sheriff's door, and when the half-awake sheriff opened his door, Harry pointed out the bird. Thompson grabbed his twelve-gauge shotgun from behind the door and fired both barrels at the bird, blowing a cloud of dusty feathers and stuffing over the water. "Old Bill was so surprised and mad, I took off to Vancouver as fast as I could," Diamond told interviewer Richard Grafton many years later. "It was a week before I let Bill even see me.".

When the interstate freeway was built through the city of Vancouver, Diamond was offended by the barren slopes of the cut. He and Ed Mayo drove the freeway at night throwing out wildflower seeds. The Department of Transportation never discovered the source of the flower display.

In spite of his pranks, Harry advanced through the ranks and was appointed chief in 1945 at the age of thirty-seven. He would be the longest-serving chief of the Vancouver Police Department. When he retired on April 16, 1962, he had tenure of seventeen years as chief. After retirement, he worked for two years as a chief deputy to the U.S. marshal for Western Washington, Donald Miller. Then he retired for good to his flower garden in the Fruit Valley section of Vancouver.

Sheriff Robert Brady had been elected as head of the twenty-six man Clark County Sheriff's Department in 1943, during World War II. During that time, the Vancouver Housing Authority had built six wartime cities surrounding the city of Vancouver. Each was just outside the city limits. They'd been built to accommodate the thousands of workers swarming into the Kaiser Shipyards, newly built on the river, and the Alcoa aluminum plant. Police and fire had to be provided for those cities. Eligible young men for those positions were rapidly being drafted into the military. Sheriff Brady sent out a plea for citizen volunteers to take over office positions to free deputies for patrol.

Brady was reelected at the end of the war, but midway into that term, he suffered a stroke. He struggled for a year to return to work. That was not to be. A series of interim sheriffs, acting sheriffs or officers in charge followed

during that time. Finally, Brady found a way to retire, with the consent of the county commissioners. The commissioners would then find a temporary officeholder until the next election. Under the law, it would be someone of his own political party, a Democrat. There were several eligible men, he knew, with experience.

Earl Anderson had a reputation as a competent and efficient manager. He was forty-two years old with a growing family. He had been listed in the 1930 census as living in Pasadena, California, with his wife and family, working as an auto mechanic. By 1937, he was living in Hazel Dell, Washington, and was the financial secretary for the Machinists Union, Local 1374. By 1940, he was the business agent for the union. His future was ensured. He became the president of the Vancouver Metal Trades Council in 1944. He had also been appointed to the Vancouver Housing Authority since its inception, overseeing the building of the six wartime cities in Clark County. He had volunteered occasionally in the Sheriff's Department to help out, and he was moving among the top political people of influence in the region. Volunteering with the local party, he'd come to the notice of the Democratic leaders in the state. When Monrad "Mon" Wallgren was elected governor, defeating the incumbent governor Al Langlie, Wallgren appointed Anderson to head up the Department of Labor and Industry. This was a prestigious appointment and a giant step up for a young man. He joined with the other heads of departments to report directly to the governor.

No one thought that the defeated Al Langlie would come back and take out Mon Wallgren after one term, but he did. All of the Wallgren appointees found themselves unemployed. County commissioners and others elected across the state were under pressure from the party to find jobs for those stalwarts. In Clark County, there would soon be an opening. On Tuesday, May 31, the county commissioners met at 10:00 a.m. and immediately went into closed session. Louis Hall was the chairman of the board, and Clarence Bone and Seth Davidson completed the panel. They emerged one hour later, and the regular meeting began at 11:00 a.m. In quick actions, with no discussion, the board accepted Sheriff Brady's retirement and appointed Earl A. Anderson as sheriff. He was sworn in immediately.

The leadership of the Clark County Sheriff's Department was now in the hands of a likable, bright and ambitious man whose experience in law enforcement amount to fewer than a dozen afternoons as a volunteer at the desk.

Things went smoothly for a while. Anderson asked for funding for more officers, pointing out that the department was understaffed because of the

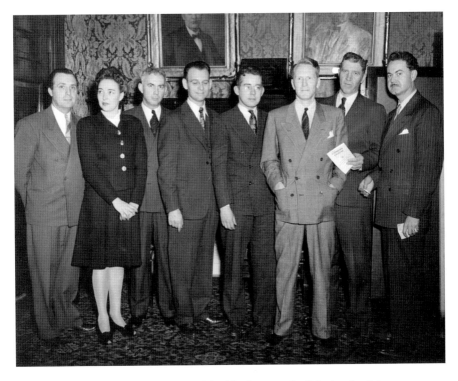

Earl Anderson stands fourth from the left in this photograph of the heads of departments appointed by Governor Monrad Wallgren. He served during Wallgren's single term in office. *Washington State Archives.*

war and the population was larger. He started a jail laundry, had the jailers trained at McNeil Island prison and started a substation at Battle Ground. He was off to a wonderful start.

Friends urged him to run for the office of sheriff at the election in 1950, stressing that all the news articles about him were so favorable he'd be a sure bet to win the election to stay in office. He would have the incumbent edge. He announced that he would seek the office.

Across the river, the incumbent edge did not help Multnomah County sheriff William Pratt. A handsome young man filed to run against him, and oh, what a candidate! Marion L. "Mike" Elliott introduced himself as a thirty-one-year-old World War II Marine Corps veteran of six and a half years with an honorable discharge. He was a graduate of the University of Michigan. The American Legion welcomed him with open arms. The *Oregonian* newspaper loved him. The voters saw a young and energetic candidate who would "shake things up."

Earl Anderson had moved rapidly up in the political world of Clark County. His appointment to the wartime Housing Authority was a big step up in his career. His rise ended with his appointment as sheriff of the county. *Vancouver Housing Authority.*

No one checked his background—none of the newspapers, none of Sheriff Pratt's supporters, no one. After the victory parties, Elliott was required by law to post a surety bond.

Unlike anyone else in Multnomah County, the Maryland Casualty Company did check Elliott's record. He was twenty-seven, not thirty-one; his formal education ended in the second year of high school; he'd never been near the University of Michigan; and he had served twenty-three months in the army and was let go with a bad conduct discharge before the war had started. If he could not make his bond, he could not be sworn in as sheriff and Pratt would continue in the office. If Elliott made bond, the voters would have to wait six months before they could recall him. His party made his bond, and Pratt would not regain his position. Eight months later, recall Elliott they did, by an overwhelming vote.

As had the Clark County commissioners, the Multnomah commissioners faced the challenge of appointing an interim sheriff. They chose a fire captain, Terry Schrunk. Schrunk, who would go on to become mayor of Portland, was, like Earl Anderson, a good-looking man. He was, in fact, a certified hero. He had been awarded the Silver Star for valor in the South Pacific.

He said, "The first thing I'll do, is to find out all I can about the office." He wanted to see whether he could handle the job. He said that he did not

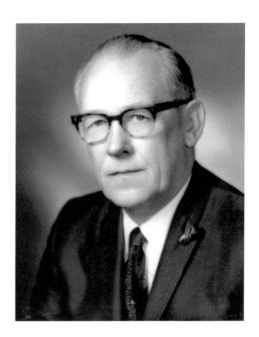

Terry Schrunk was a longtime firefighter when he was appointed to the office of sheriff of Multnomah County. He would parlay that appointment into the office of mayor of Portland, Oregon. *Author's collection.*

intend to jeopardize his fourteen-year seniority in the fire department until he found out what the new job entailed. He really had no idea.

He obtained a leave of absence from the fire department and was sworn in as sheriff of Multnomah County on Tuesday, October 25, 1949. The investigation of the crime against JoAnn Dewey would now fall on one old-time police chief with two older detectives, two inexperienced sheriffs and the state police, whose primary duty was traffic enforcement.

The stunned community would look to these men to ensure their safety.

THE CRIME

It was the screams that attracted attention that night. Ann Sherbloom, a nurse in the pediatric ward, described them as the most horrifying sound she had ever heard. "You knew that someone was in mortal danger. I keep hearing those screams," she would later testify. She told the head nurse what was happening. Babies were crying. She went to attend her patients. The screams suddenly stopped.

At 11:30 p.m., the first call was made to police headquarters. "Come at once!" the caller pleaded. "Two men are beating a girl on the street outside and trying to force her into their car!" It had been just eighteen minutes since JoAnn had called her mother.

In the Central Court Apartments, Clarence Bone, a Clark County commissioner, heard them too. He ran outside to see what was happening. There he saw two men wrestling with a young woman. She screamed, kicked and clawed. She grabbed onto a light pole and dug her nails into it. The men pounded on her hands.

A veterinarian, Dr. Chester N. Thackeray, heard the screams echoing in the street as he was about to go to bed. He took the stairs two at a time. He called out, "What's going on?" V.F. Andrews, another resident at the apartments, looked out his window and saw the fight going on. Everett Allison dropped the book he was reading and ran outside.

"Shut up, she's my wife," one of the men yelled.

"No I'm not, no I'm not!" she replied. Her cries were not answered; she was dragged toward the car.

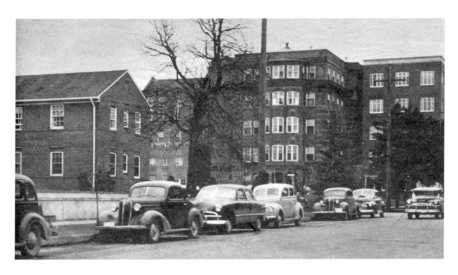

The scene of the crime. St. Joseph's Hospital looms over Twelfth Street and the Central Court Apartments. JoAnn almost made it to the hospital. The attack began at about where the large tree stands in this photo. *Author's collection.*

A 1941 Buick similar to the one driven by Turman and Utah Wilson. *Connors Motorcar Company, Carlo Connor.*

"She's had too much to drink!" he called out.

The woman continued to cry for help until a punch to her face silenced her. She slumped and was easily manhandled into the back seat of the car. The car roared off down Twelfth Street and turned on Broadway. As violent as it was, the abduction took only a few minutes and was over before anyone had a chance to react. It was very dark, there was but one streetlight and the

car was between the witnesses and the light. There was no moonlight, as it was a new moon. No one got a license plate number. They decided that it was just a husband and wife affair. V.F. Andrews agreed that it was probably just domestic but said that the girl appeared to be badly hurt.

The police station was just a few blocks away, at Washington and Eighth Streets. With red lights flashing, a police car turned onto Twelfth Street. When they saw the number of people out on the usually quiet street, they knew that they were already too late. Sergeant Carl Forsbeck and Patrolmen Harold Edmonds and Frank Irwin began moving among the witnesses to take information.

Carl Forsbeck had been on the Vancouver Police Department since 1937, a sergeant since 1944. Hal Edmonds became a police officer as a World War II temporary but was made a regular officer in 1946. Frank Irwin was the newest officer, having been hired in June 1946.

The three questioned witnesses and took notes. They agreed that the car was a dark, four-door, 1940 or '41 model. V.F. Andrews was sure that it was a 1940 Buick. He was a car salesman, he told them, and he knew cars. He'd seen the car from his window and had seen the "V" emblem. Forsbeck radioed Captain Ed Mayo at headquarters, and an alert went out to all local officers. Mayo called the sheriff's office and the Washington State Patrol.

To assist with questioning the nurses, Policewoman Irene Borden joined the officers. The girl had been well built, they said, and pretty. She had dark hair. She wore a three-quarter-length coat. Nobody recognized her; nobody knew her. They all agreed on that—she was a stranger. The officers assumed that an unfamiliar woman on the street at that time of night might possibly be one of the nurses at the hospital. But before going to the hospital, there was a crime scene to be investigated.

Would there be tire tracks? By the light of their flashlights, they walked the block to see if there might be a patch of mud that would yield tracks. There was nothing. Telling the onlookers to stay on the lawn of the apartments, they began a careful, step by step, inch by inch inspection of the street. When they finished, there was just a small handful of items collected. There were some cigarette butts, matches and some hairpins. There was a large brown button, a silver barrette and a brown leather strap possibly torn from a purse. There was a stubby-necked bottle of Olympia Beer, lying in the gutter, still with a small amount of beer in it and large bubbles. Sergeant Forsbeck found that and knew that bubbles in beer did not stay large for very long. He borrowed a pair of tongs from one of the onlookers, carefully retrieved the bottle and bagged it.

Right: Carl Forsbeck, who was credited with discovering the beer bottle that led to the conviction of the Wilson brothers. *Vancouver Police Department.*

Below: The only physical evidence against the Wilson brothers was the stubby-necked Olympia beer bottle, some buttons and a broken strap from a purse. *From the* Vancouver Columbian.

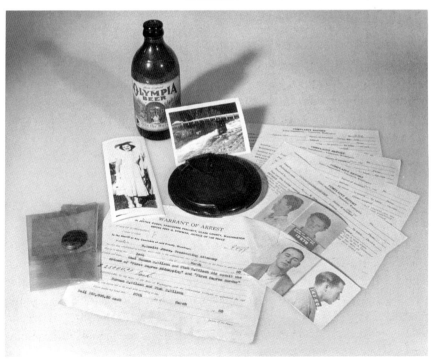

Next, they moved to the hospital. All female employees were accounted for; they were found in the nurse's dormitory or at their work stations.

The sheriff's office was notified that there had been a fight at Twelfth and D Streets and that violent arguments such as this might flare up again later. Throughout the night, agencies across Clark County were searching for a dark car, maybe a Buick, with two men and a woman. That was all that they had.

Utah and Turman, later testimony would show, drove across the Interstate Bridge into Portland. There were many dark and secluded roads in Portland in the '50s; they chose one of them to complete their work. When they opened the back door of the Buick, they discovered that she was dead. Lying unconscious and face down on the floor in the back seat, she had asphyxiated.

They knew that the Buick had been seen; it was essential that they change cars. Their brother Grant, the upright member of the family, had several cars that he allowed his brothers to use whenever they wanted. So, they headed for Grant's home in Camas. He was already asleep. There they manhandled JoAnn's body into another of Grant's cars, a tan Pontiac five-passenger coupe. Somewhere they stopped and stripped off her clothing. Someplace, they buried her clothing, which has never been found. Back again at Grant's home, working feverishly, they moved her naked dead body into a Chevrolet coupe. During these frantic transfers, one of the men sodomized her corpse. The pair then drove the coupe with her lifeless body to the Wind River. They circled behind the St. Martin Springs Resort to a low footbridge. There the pair threw her into the water.

They headed for their mother's house in Fern Prairie. As they approached, they saw three cars parked near her house. They were dark sedans with parking lights on. They were sure that they were police cars. They decided to spend the night in a wooded area north of Lackamas Lake. At least that's one of their stories. The other version was that they drove to the Cline home, where Utah lived with his wife and mother-in-law, Gladys. They looked for police cars there and waited for a few hours. Then they returned to Camas.

The next morning, Monday, the twentieth, they met with Grant. They told him that they'd probably have to leave the state—there had been a kidnapping, and based on their criminal records, they knew that the police would be looking for them. They both assured him that they had had nothing to do with the crime.

When Utah and Turman arrived back at the Cline home, Gladys was upset. A man named Carl Whitney, a friend and fellow parolee of Utah's,

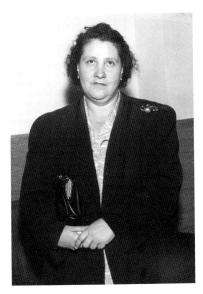

Left: Gladys Cline was Utah's mother-in-law. She was a strong defender until the trial was over. She was always quick to remind reporters that her name was spelled with a *c*, not a *k*. *From the Vancouver Columbian.*

Below: The brothers drove back and forth across the Interstate Bridge during the first few days after the crime. Later, Utah would testify that they'd made so many trips he couldn't remember them all. The bridge then was a single span, with traffic in both directions. *Author's collection.*

had visited. He asked for Utah. He said that a power saw had been stolen, and he was afraid that he'd be a suspect. He asked if Utah had taken it. Utah denied any knowledge of a power saw but told Gladys that he probably should lie low for a while.

That evening, Grant, still being the father figure to the brothers, met with the pair at Gladys Cline's home. They talked about the power saw. Turman immediately realized that this gave them a reason to flee. He insisted that

Utah must leave town. He told the group that he must leave with Utah to take care of him. He pointed out that the newlyweds, Utah and Lucille, had never had a honeymoon. They could leave town and consider their alternatives. They all decided that Turman, Utah and Lucille would go to Portland and check into a hotel. Lucille loved that idea; she had never stayed in a hotel. They left for Portland in the tan Pontiac.

In Portland, they rented another car, a Dodge. They thought that if they moved the Pontiac from place to place, from street to street, it would appear that they were using the car. An abandoned car would attract police attention. They were well known to Portland police as well. They also figured that no one would be looking for the Dodge. They switched cars several times, just in case they were being followed.

In the rental car on Wednesday evening, they drove back to Camas to meet with Grant. They discussed options and made plans. Grant, as usual, was the practical one. He drove them back to Portland, where Turman bought an Oldsmobile under the name Ted E. Davis. When asked later why he had used an alias, his reply was that for several years, he would use a fictitious name if he had to sign any paper. They arranged to have the vehicle documents mailed to Grant's house.

As they had since they were children, the brothers returned again and again to Grant. They visited him on Friday night and again on Saturday. They were now convinced that they had to flee. The newspaper headlines were full of the JoAnn Dewey story. They saw that every police agency was involved. It was time to go. They left Lucille at home and headed for California, driving the Oldsmobile.

THE SEARCH

On Monday morning, Anna Dewey drove into Vancouver to pick up her daughter at the hospital. She was alarmed to find that JoAnn had never reached there. Further terror struck as the nurses told of the horrific screams heard the night before. She called Opal Lewis in Portland, desperately hoping that JoAnn had changed her mind and returned home. She hadn't. Anna drove to the Vancouver Police Department, where an officer told her that she should make the report to the Clark County Sheriff's Department since Meadow Glade was in the county.

The sheriff's office was just a few blocks away. She went there to make a report. The desk officer took a missing person report. Meanwhile, Commissioner Clarence Bone had approached a deputy, Arthur Swick, in the courthouse garage and had told him of the previous night's events. When Swick saw Mrs. Dewey at the counter, he asked her if she thought that JoAnn might be the victim of the prior night's occurrence. With a hand over her heart, Mrs. Dewey nodded, tears beginning to form in her eyes.

Swick called the Vancouver Police Department desk officer and told him that he was sending Mrs. Dewey back to him and that he should make a report—this time the chief, Harry Diamond, was waiting for her.

Harry sat down with Anna Dewey. He showed her the barrette, the button and the leather strap. JoAnn did carry a brown purse, Anna said. She wept at the sight of the barrette. "She had two of them." The distraught mother identified the other items as belonging to her daughter. A name was attached to the alert: JoAnn Louise Dewey.

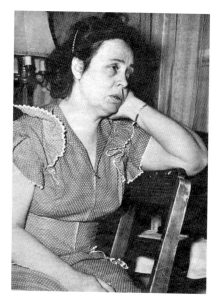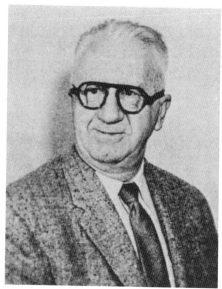

Left: Anna Dewey tearfully waits for news of her missing daughter. The weeklong search for JoAnn was an ordeal. *From the* Vancouver Columbian.

Right: Floyd Borgan was one of the gray-haired detectives from the Vancouver Police Department. He retired from the department in 1957 with the rank of captain. *Vancouver Police Department.*

Chief Diamond assigned two detectives, Floyd Borgan and Jason Ulmer, to devote their full time to the case. Another detective, Glen Anguish, was assigned to help. They re-interviewed all the witnesses from the night before. An appeal went out to the mystery woman in the white coat who had been assaulted the week before to come forward, knowing that she was their best lead. They promised complete confidentiality. The two men who had helped her were questioned again, but they could add nothing. She never appeared, and she was never identified.

Telephone tips began to come in. Dark sedans were seen, and suspicious people were spotted. Stories came of neighbors who were behaving mysteriously. All the tips were noted. Portland chief of police Charles Pray called the detectives. The case closely resembled a kidnap and rape from a decade earlier. "You check up on the Wilson brothers," he advised. "It looks like they're up to their old tricks!" He was thanked, and his tip was noted and put with the rest in the stack. The tip stayed in the stack.

Jackie Crull, a neighbor of the Dewey family in Meadow Glade, called the sheriff on March 21 to say that she had evidence of the affair between

JoAnn and the deacon Donald Strawn. Sheriff Anderson hurried out to meet with her. Crull pointed out the Strawn home and that of his brother and nephew, sixteen-year-old Fred Strawn. She told him of the phone call that Fred had received from JoAnn that night. She thought that Strawn's wife knew of the affair. She told him that her mother, Dora Crull, had talked to JoAnn about breaking off the relationship. Grayston Crull, Jackie's father, had talked to Strawn and had urged him not to see JoAnn. Did Donald Strawn's wife know of the affair? Yes, as she had told the sheriff that her husband had been infatuated with JoAnn; she knew that they had known each other for a long time but noted that the relationship had ended a few months before.

Sheriff Anderson talked to Fred Strawn first. Fred told them of the phone call, but he was sleepy and told her to call back. He was so sleepy, he said, that he barely remembered the call. He told them of a boyfriend of Joan's who lived in The Dalles, Oregon. He thought that Opal Lewis, with whom JoAnn lived, could give them a name and that the sheriff should talk to Joan Crawford, a close friend who once had lived in Meadow Glade. He said that Crawford had been married and divorced.

At midnight, Anderson, accompanied by Deputies William Scott and Bill Farrell, called on Donald Strawn. The pajama-clad deacon answered the door and invited them in. Yes, he'd known JoAnn for several years. They'd been friendly, but he had no idea where she might be and had no idea who had abducted her. Where had he been on Sunday night? He'd been at home and had gone to bed at 9:30 p.m. His wife had been away for the weekend, but his nine-year-old son was at home with him. He agreed to meet with the officers at the sheriff's office on Wednesday at 5:00 p.m. Anderson was sure that they had their suspect, as Strawn had a weak alibi for Sunday night.

At the sheriff's office, Donald Strawn readily admitted the love affair with JoAnn and that he had indeed considered a divorce. He said that the last time he had seen JoAnn was just three weeks earlier, when he'd picked her up in Portland. They had driven up to the top of Rocky Butte, a cinder cone of an extinct volcano that rises to the east of Portland. They had parked there and talked, he said, and decided to break off the affair. He had discovered that she had been seeing other men as well. He denied that the affair had ever gone beyond kissing.

Strawn would be summoned to the sheriff's office several times. He admitted to phoning JoAnn every day leading up to the day of her disappearance. If they'd broken off the romance, why would he still call her? In his report, Deputy Neal Jones wrote, "I asked him what he wanted to see

her about. He said he thought his advice and counsel would be of value to her. I asked him if this meant he wanted to act as sort of a moral protector for her. He replied, 'yes, something like that.'"

Monday passed, and Tuesday dawned with no trace of the car or JoAnn. She did not show up for work Tuesday morning. Now they were positive that JoAnn was the victim in the kidnapping the night before. There was nothing to be gained by withholding news; they released a statement.

The mayor, Vernon B. Anderson (no relation to the sheriff), called a conference of the three law enforcement agencies, including Chief Diamond of the Vancouver Police, Sheriff Anderson of Clark County and Washington State Police sergeant James D. Coshow. They were to share the leadership of the case. That would prove to be a mistake. Sheriff Anderson, a key figure, knew nothing at all of homicide investigation. Sergeant Coshow had never been involved in one and so chose to only add logistical support.

The crime was the lead story on every news broadcast and was the headline on every local newspaper. The story was the subject of every conversation. There was still no word. Vancouver mayor Vernon B. Anderson had broadcast a radio appeal for volunteers to help search for JoAnn. By midmorning, a crowd of four hundred people was at city hall. They had cars and horses, and there were even a few with private planes ready to fly from the downtown airport, Pearson Field.

The searchers divided the county into twenty-six squares, with searchers assigned to each square. Rangers in the Gifford Pinchot Forest were asked to search cabins and sheds. Farmers and ranchers were urged to check barns and outbuildings.

The general store in the little community of Ellsworth upriver on the Columbia had mysteriously burned to the ground on Sunday night. Vancouver firefighters meticulously sifted the ashes on the slim chance that the killers might have set fire to the building to destroy the body. No

Noble Clyde Dewey, JoAnn's father, shows the strain of waiting for word about his missing daughter. *Author's collection.*

evidence was found. The fact that they were looking for a body showed that most were sure that the girl was dead. Were she alive, they assumed, she would have surfaced by now.

The weather had cleared somewhat, with the temperature hovering near fifty degrees. It was mostly cloudy during the day, with showers at night. The searchers had combed the nearly deserted Vancouver Barracks. The 680-acre military reservation was a neighbor to the hospital and the scene of the abduction. The row of houses that were home to officers had less than a score of residents. The barracks were virtually empty. World War II had ended, and the base was no longer needed. There were thousands of places to hide. Searchers fanned out over the base; wooded areas, buildings, shed—all needed to be checked. The barracks extended to the north bank of the Columbia River. A Coast Guard station marked the edge. A concrete plant was next to that. The rocky drop-offs along the river were searched as well. Nothing was found. The Coast Guard searched the river's edge.

East of the barracks, between the river and Mill Plain Road, a mausoleum had been partially built and abandoned. Ten police reserves were sent to search that area on a tip. Nothing was found there, either. Another call went out for citizens to volunteer cars and trucks, as they were short of transportation.

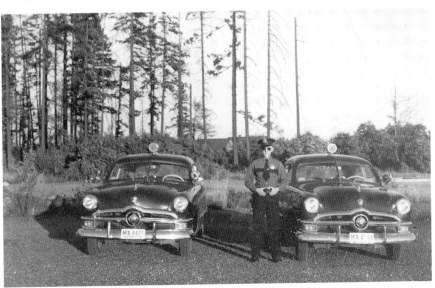

Two of Vancouver's 1950 Ford police cars stopped on the army's military reservation. Its six hundred acres were thoroughly searched. Officer Bob Axlund stands between the two vehicles. *Axlund Family Collection.*

Lew Norton, a fingerprint expert, holds the beer bottle recovered at the crime scene. *Author's collection.*

A frantic call brought police to a shack along the Washougal River near the city of Washougal. Two men and a girl were seen there. A large group of police arrived, along with officers from Washougal and the sheriff's office. It was just a man and his wife with their son who'd just moved in to ready the place for summer.

Detective Borgan announced that fingerprints had been raised from the beer bottle that had been found in the street. They sent a copy off to the Federal Bureau of Investigation. They knew that it would take days or weeks for a response, but it was all they had.

City and county officers pored over records of sex offenders; dozens of men were brought in, questioned and released. Detectives talked to friends and neighbors of the missing girl in Meadow Glade and Battle Ground. They asked for names of boyfriends and acquaintances, and as they interviewed those people, they asked for other names, building a web of those who had crossed JoAnn's path in her eighteen years.

The Seventh-day Adventist churches formed posses to comb Leverich Park and Vancouver Lake. They held services praying fervently for JoAnn's safe return. In Leverich Park, they found a bloodstained shirt. The "blood" turned out to be lipstick. The bridge tender on the Interstate Bridge found a bloody undershirt hanging from a girder. That "blood" was found to be shoe polish.

The days passed. Tips poured in, along with offers of money to the Dewey family to raise a reward fund. Two women, Betty Smith and Lois Hennessey of Oregon City, drove to Vancouver and volunteered to search. Three more days passed. They were told that it was men's work but that they could make coffee. The pair declined the coffee position and set out to search on their own. They decided that a hot spot would be the area above Lackamas Lake. In a trash heap there, they found Oregon plates that looked fairly new. They rushed them to Vancouver, where it was found that they were registered to Grant Wilson of Camas. Sheriff Anderson interviewed Grant, who readily admitted that, yes, they were for his car, a Buick, which was parked in front of his house. He'd exchanged the Oregon plates for Washington plates. He'd thought the plates were still in the trunk of the car.

JoAnn was still missing. Her parents pleaded for help and news. A call came into the home from one Colin Cree. No one in the family knew him. He said that he had information on the case. Anna Dewey called her neighbor, Harold Cusic. He was a Washington State patrolman. What should she do? Harold told her to invite Cree to his brother Howard's house and to call the sheriff. He added that he was also en route and would meet them all there.

That would be the undoing of Sheriff Anderson. The repercussions from this would follow him throughout the year.

THE EMBATTLED SHERIFF

Colin Cree had knocked on the door of Mrs. James Nelson, on March 24. Mrs. Nelson was one of the witnesses to JoAnn's abduction. Cree told her that his sister was a friend of JoAnn Dewey's. He had wanted to assist in the search but had been unable to do so. His speech was rambling, and his eyes wandered. He wanted to come into the apartment. She became alarmed, shut the door and called the police.

Later that day, Cree phoned Mrs. Dewey and told her that he had information on JoAnn's whereabouts. Her heart leaped, and she called Harold Cusic, a Washington State patrolman and friend. What should she do? He said to have Cree come to his brother's house and to call the sheriff—he would meet them there. Harold and his brother Howard, a firefighter, along with their father, Hurshel, were neighbors and friends of the Dewey family in Meadow Glade. The Deweys had increasingly relied on their neighbors for strength and support.

Clark County had been plagued with safecrackers. Victims of the thefts called on the Sheriff's Department to do more to put an end to the crime spree. On March 25, two of his detectives, Art Swick and Bill Scott, arrested three men accused of the safecracking. Sheriff Anderson was delighted. He prepared a press release announcing the captures. Then he bought a fifth of whiskey to celebrate with the detectives. There are twenty-seven one-ounce shots in a fifth of whiskey. The bottle was almost empty when Anna Dewey called.

The sheriff and his two deputies ran to a police car and drove from the courthouse to Meadow Glade. They entered the house and saw Cree. The two

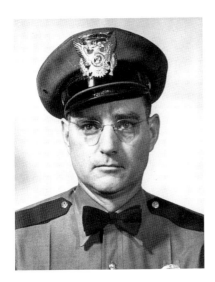

During the melee that involved the sheriff at the Cusic home, trooper Harold Cusic took charge and calmed a chaotic scene. *Washington State Patrol.*

detectives knew him as a sex offender. In 1946, Cree had been convicted of contributing to the delinquency of a minor. Today, that would be called child molestation. Cree was confined to the state hospital. Once out of the hospital, he had molested another young girl. He was facing trial again.

According to the neighbors, when the two detectives saw Cree in the home, they began shouting at him. Cree stood up and swung at the officers. They and Anderson grabbed him and threw him out of the house. Anderson denied this, saying they'd only walked him about sixty-nine feet from the house. Anna Dewey followed, pleading that they let Cree tell them what he knew. Mrs. Dewey was knocked down just as Washington State patrolman Harold Cusic drove into the yard. He jumped out and grabbed the furious sheriff. He walked Anderson to the police car and told him and the two detectives to get out of the area immediately.

The next day, the Deweys, along with the neighbors who had been at the scene, attended the county commissioners meeting. They demanded that they fire Anderson. The commissioners weren't sure if they could fire the sheriff, or if he would have to be recalled, just as if he'd been elected. R. DeWitt Jones, the county prosecutor, told them that they could not. He'd been sworn in, and he'd have to be voted out.

One member of the group, Grayston Crull, filed a complaint in justice court charging Anderson, Scott and Swick with voluntary intoxication and creating a disturbance.

State trooper Harold Cusic had not arrested the sheriff at the scene because he knew that the only person who can arrest a sheriff, even an appointed one, is the county coroner. This derives from English common law—the sheriff is the reeve of the shire and the coroner represents the Crown.

Coroner Roy Spady was called, and he then served Anderson, Swick and Scott with the warrant. The trio hired noted attorney D. Elwood Caples, and a trial date was set.

Some weeks later, in a speech to precinct committeemen, Sheriff Anderson said the charges against him were lies and made up for political purposes. He said that neither he nor either of the deputies had had a drink on that day. He had not manhandled Cree, he swore; he had only pulled him by the arm for those some sixty feet. He went on to say that because he had discovered the affair with Deacon Strawn, people were out to get him. He had made his mind up that JoAnn had been killed by someone who knew her. He would continue to investigate the deacon for months.

He told his audience that he had apologized to Mrs. Dewey before he left, that he was sorry the matter had come up and that her friends should have protected her against charlatans such as Cree. Then he switched to another topic, that the people who had filed charges against him were progressives, part of "Pennock's Gang." Pennock was a leader of the Old Age Pensioners movement. Then he added that Colin Cree had collected a group of Progressives to confront him, including Howard Cusic. He cried out, "The Progressives have been out to get me for 15 years!" Anderson concluded, "I have just started to fight. I don't want to embarrass any candidate or any democrat. Just let me handle this and I'll be here in the fight in November and thereafter," the *Columbian* reported.

The sheriff had thought that the party in his office would be kept secret. DeWitt Jones, however, found out about it. There were other deputies in and out of Anderson's office that day. Jones asked Deputy Leslie Wierlesky if he would testify as to those events. Wierlesky, despite advice to keep his mouth shut, said that he was reluctant to testify against the sheriff, but if he were subpoenaed and put under oath, he could do no less than tell the truth. To do otherwise would be perjury. Another deputy, Benjamin Ennenga, said the same.

The sheriff asked both men to testify for him. They told him that they could not, and would not, perjure themselves. Anderson fired both men. Anderson had deputized all three county commissioners in September 1949. One of them was Clarence Bone, an original witness to the kidnapping.

At the meeting of the commissioners after the confrontation, Bone moved to ask the sheriff for his resignation. There was no second. Enraged, Anderson attended the next commissioners' meeting. There, he fired Bone as a reserve deputy on grounds of cowardice. In a lengthy letter, he charged that Bone had failed to take action when he witnessed the girl's struggles. Further, he had not called the sheriff to report it; there were three patrol cars in the vicinity that night, and he had been in one of them.

Bone responded that he had indeed responded, making a witness statement to the Vancouver police. He handed in his commission but kept his badge. He averred that it had been a gift from the sheriff and he'd hang on to it.

Clarence Bone, a Clark County commissioner, was a witness to the kidnapping. He had been one of the three commissioners who appointed Earl Anderson. It cost him his seat. *Chet and Ann Rayfield Collection.*

Civic groups one after another called on the sheriff to resign. He refused. He still insisted that the accusers lied, that it was still all about JoAnn's affair with the deacon. The answer to the crime, he claimed, lay in Battle Ground.

The sheriff's trial in early May took just one day. Both detectives and Sheriff Anderson claimed innocence. Anderson had made a statement to the press that he had, in fact, not been drinking. When Anderson's attorney, D. Elwood Caples, asked him how much of the fifth of whiskey the three had consumed, he was taken aback when Anderson proudly answered, "All of it." The jury took just two hours to deliver a guilty verdict. All three were fined.

In the meantime, Colin Cree, at the center of the fight, pleaded innocent to two counts of carnal knowledge and contributing to the delinquency of a minor. He had been arrested leaving JoAnn Dewey's funeral.

On June 5, 1951, one year later, a Clark County jury awarded Colin Cree token damages of $100 in a civil suit that he'd brought against Anderson, Swick and Scott. He had asked for $5,000. He'd claimed that he suffered loss of hearing, severe pain and other injuries. Under cross-examination, he admitted that he had worn a hearing aid for some time before the fracas.

The mistakes that were yet to be made would divide a community. The sheriff's downward spiral had steepened. It would seem that the harder he tried to trivialize the event, the more the public opinion hardened against him. Around the small tempests that were the sheriff's problems, however, the larger storm was still raging. The search had continued. The day after the brouhaha at the Cusic home, a grisly discovery had been made.

JOANN FOUND

St. Martin's Springs Resort, now called Carson Hot Springs, looks much the same today as it did in 1950. Secluded on a bluff beside the rapidly flowing Wind River, it had been built in 1901 to offer spartan accommodations to those seeking the healing mineral spring baths. Swirling past the springs, the Wind River is noted for its spring run of salmon and trout. The season usually opens in late March.

Three fishermen set off from Yakima to fish the Wind River on March 26. They started at the High Bridge but had no luck, so they worked their way downstream, reaching a point just downhill from the resort near a footbridge.

Gerald Frandle, Ray Lowry and Robert Rummel, wearing waders over their Levi's, waded out onto the gravel bar. They stopped cold when they saw the nude body of a woman, lying prone in the water, her head turned to her right. Her face was battered and her hair matted with blood. A visible gash ran from her forehead to the crown of her head. There was a hole in her abdomen. They'd read about the search for JoAnn in the newspapers and were certain that they'd found her.

Frandle stayed with the body while Rumnel and Lowry ran up to the hotel to call police. He was later to say, "I saw a lot of corpses while I was in the war, but nothing like this, all beaten to hell."

In Skamania County, the county prosecutor is also the coroner, and all deputy prosecutors are also deputy coroners. The county prosecutor/coroner who responded was Raymond Sly, an experienced attorney. Before his election to the prosecutor's office, he had been the first city attorney for

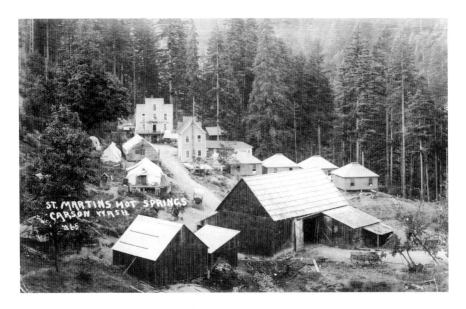

Above: St. Martin's Springs, now known as Carson Hot Springs, stands on the Wind River. A little-known road winds behind the resort to the footbridge from which JoAnn's body was tossed. *Author's collection.*

Left: Robert Rummel and Ray Lowry, two of the fishermen who stumbled on JoAnn's body in the Wind River. *Richard Grafton Collection.*

the town of Stevenson, Washington. He would later assist in the prosecution of the case alongside R. DeWitt Jones.

Sheriff Amos "Jim" Reid soon arrived and set up a command post at the St. Martin's Hotel. He agreed that it was probably JoAnn. A hurried call was put in to Clark County to Sheriff Anderson. He asked the sheriff to bring cameras with him. Anderson notified the press of the discovery. Along with his chief deputy, Neal Young, and Detective Al Swick, he sped off to Carson. He did not, however, call Chief Diamond at the Vancouver Police Department. Harry Diamond learned of the discovery when a reporter called him. Harry was known for colorful language, but those close to him say that he surpassed himself that day.

Sheriff Anderson arrived with his two detectives and a cameraman. He first asked Sly about the cause of death. Sly told him that he was not a doctor and that he needed a good pathologist to tell him that.

Also called was Harold Cusic, the Washington State patrolman who'd counseled Anderson the day before at his brother's house. He had known JoAnn well and was asked to identify her. He waded out into the icy water, nodded his head and said only, "I recognize her."

Raymond Sly gathered a group of six men—locals, hunters and fishermen—who'd been attracted by the excitement and swore them in as a coroner's jury. As a drizzling rain misted around them, the three fishermen described how they'd found the body. Harold Cusic related the identification process. He again identified the pitiful remains as JoAnn Louise Dewey. They all agreed that it was death by homicide. All were positive. They were then excused. They were advised that they'd be recalled after the autopsy by forensic pathologists.

In Washington State, a coroner does not have to be a doctor or even have any medical experience. It is an elected position, often filled by a funeral director. This coroner, Roy Spady, was a manager at Jack Spady's Ambulance and Auto Parts Store. That was the sum of his medical expertise. But he had the ambulance in which to transport the remains back to Vancouver.

The men wrapped JoAnn's battered body in blankets and called Clark County coroner Spady to make the arrangements to bring the body back to the Evergreen Funeral Home in Vancouver. There, Howard L. Richardson, MD, from the University of Oregon Medical School, performed an autopsy.

The autopsy revealed several things. JoAnn did not die of the blows she suffered; she died of carbon monoxide poisoning. The meat substitute that she had eaten was analyzed to determine the time of death. She had lived only five to six hours since she had dined. She had been sodomized after death.

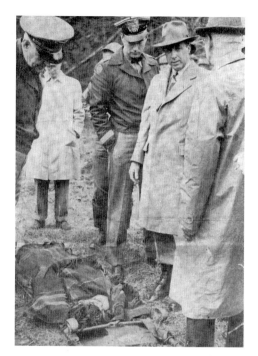

Right: Washington state trooper
Harold Cusic identified JoAnn by
simply saying, "I recognize her."
Clark County Sheriff's Department.

Below: Spady's Ambulance and Auto
Parts Company, which was located
at Forty-Seventh and Main Streets in
Vancouver. *Author's collection.*

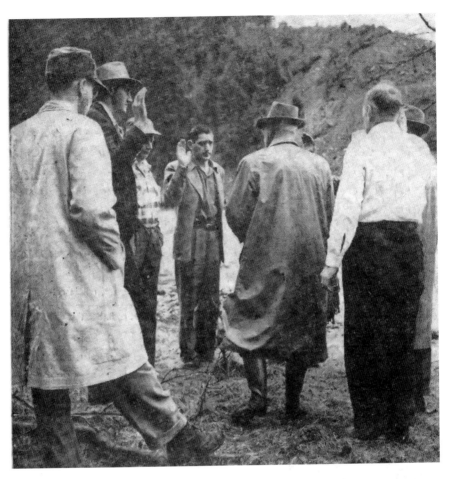

Skamania County prosecutor/coroner Raymond Sly called together a group of hunters, fishermen and Carson townspeople to form a coroner's jury on the bank of the Wind River. They quickly found that JoAnn's death was undoubtedly homicide. *Richard Grafton Collection.*

Sheriff Reid ordered a search both up and down the river and on both bridges. They looked for tire tracks on the road down from the resort. They searched for clothing and any clue that might have been left. At the end, nothing was found. The rain had washed away any tracks.

The investigators from all three departments—the Clark County Sheriff's Office, the Vancouver Police Department and the Washington State Patrol—agreed that the killer or killers had to be local. The area was remote and difficult to find unless it was known. The footbridge was hidden

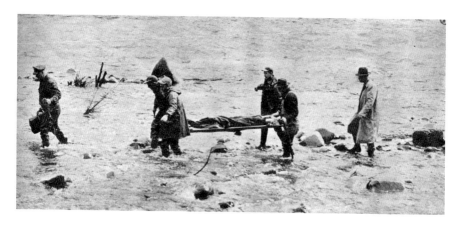

The two fishermen assist the deputies in bringing the pitiful remains to shore. *Luse Family Collection.*

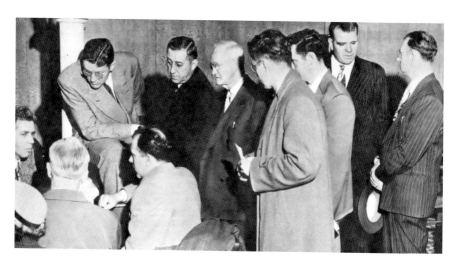

Dr. Richardson's press conference draws reporters and law enforcement. Borgan and Ulmer have their backs to the camera. *From left to right:* a reporter, Sheriff Jim Reed, Raymond Sly, two unidentified men, Chief Harry Diamond and Sheriff Anderson. *Richard Grafton Collection.*

by trees. They all agreed as well that the discovery was fortuitous. Had it not happened for another few weeks, the annual spring freshet, which came as snows on the mountains melted, would have washed her body out into the wide Columbia River. That would have delayed discovery for months if not longer.

JoAnn was laid to rest at the Brush Prairie Cemetery after a funeral attended by more than one thousand people in her Seventh-day Adventist church in Meadow Glade. Among the mourners was Colin Cree, the focus of the sheriff's problems. He was arrested on the warrant for contributing to the delinquency of a minor as he left the church.

What was left now was to find out who had robbed the Dewey family of their youngest child.

THE INVESTIGATION

JoAnn's death by carbon monoxide suffocation opened another avenue of investigation. Chief Diamond put out an alert asking anyone with knowledge of a 1940 to 1942 Buick with a defective muffler to report it. He sent fliers to garages in the area.

The little-known logging road that led to the footbridge was a strong lead. The killers had to be locals. Skamania County sheriff Jim Reid sent searchers out into the foothills of the Cascades to talk with ranchers and farmers. The state patrol sent extra manpower to assist. They had the fingerprints from the beer bottle, a button, a broken leather strap and a description of a car.

The Portland chief of detectives, William Brown, who had been reading about the case, called Chief Diamond. Just as had Purcell, he remembered the Wilson brothers. As he described the earlier crime, Diamond recognized the family as well. He immediately sent a copy of the fingerprints from the beer bottle by special messenger. Would they match Turman's?

Diamond called Sheriff Anderson. They headed out to Fern Prairie to talk to Eunice Wilson. She was the local Sunday school teacher in the small community. She told the two lawmen that all her boys were good boys. They'd made some mistakes, sure, but were basically god-fearing young men. Turman had been living a decent life and was working in the finishing department at the Pendleton Woolen mills in Washougal, a city east of the cities of Camas and Vancouver.

The two followed up on the information, heading directly to the woolen mills. They met with Charles K. Bishop, the manager of the mill. Bishop

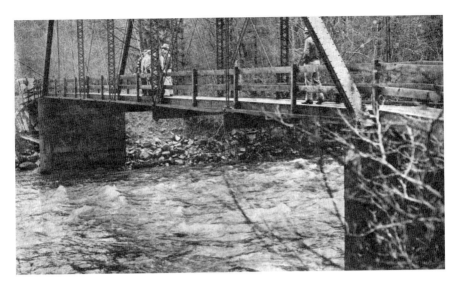

The low footbridge over the Wind River. Officers from two counties searched the bridge and the banks on both sides of the river. No clues to the crime were found. *Luse Family Collection.*

told them that Turman had been "doing very well" at the mill and was being considered for a promotion. Now, however, they had no idea where he was. He hadn't shown up for work on Monday. Bishop told them that Turman had worked in the finishing department starting on October 3, 1949. He'd started at $1.20 per hour in February 1950; he was now a "washer helper" at $1.95 per hour. He worked steadily without absences from October until March 17. On Monday, March 20, he left word, through Grant, that he'd been called to California and would be back on March 23. On March 23, however, Grant requested termination of his brother's employment since he would not be returning.

The Portland detective Bardon Purcell had some other possible leads: a taxi driver had been hanging around the sanatorium where JoAnn worked, harassing the young girls there. He'd check him out and notify Diamond if he found anything. He did follow it up and, for a short time, was certain that the cab driver had been in Vancouver, but it turned into another false lead.

Another stir erupted when Sheriff Frank Tamblyn from Thurston County called to report bloodstained clothing found along the roadside near Olympia. The clothing was soon identified as belonging to the victim of a fatal traffic accident there.

Yet another lead from Skamania County sheriff Reid came to nothing when a black Buick sedan was found abandoned, with blood and hair in the back seat. The owner, confronted by the three officers, explained that he'd been hunting and burned out a tie rod coming home. He showed them the deer as proof. They took samples of the deer's hair and blood just to be sure. The evidence was indeed from a deer.

Still another false lead happened when a car was left at a service station for a day or two at a point very close to where JoAnn's body had been found. The odd thing was that it was registered to Morris A. Yaw, a twenty-year-old who lived at the Seventh-day Adventist Columbia Academy in Meadow Glade. However, a check by Detective Neal Jones affirmed that Yaw had been at the academy the night of March 19, had gone to bed at 9:30 p.m. and had arisen on Monday at 6:30 a.m. and attended worship. He'd had car trouble driving back from Yakima a few days before and had left the car there.

To further disappoint Vancouver detectives, Bardon Purcell called with bad news. The fingerprints from the beer bottle did not belong to Turman Wilson. The sun went down on Wednesday with no progress. On Thursday morning, the thirtieth, there was a possible break, but it didn't sound too promising. Portland chief of detectives William Brown called Harry Diamond at home.

"Are you positive that the car was a black Buick?" Brown asked. Diamond was nearly positive. "Why?" Brown replied. Portland officers had found a tan Pontiac coupe with Washington plates. It had bloodstains, a large tan button and some bits of stuff that might be broken teeth. They'd tested the blood, and it was human. JoAnn had been wearing a tan or rust-colored coat, Diamond knew. He took down the license number, called his office and asked that they check the plate number. There might be fingerprints. The detective chief had asked Harry to send a copy of JoAnn's prints.

The chief called Sheriff Anderson. Would he send JoAnn's prints to Portland? Anderson had not had JoAnn's fingerprints taken. There were no fingerprints of the victim? Diamond's face reddened. Why not? The sheriff had seen no need to take prints since they knew who she was. The coroner did not know that it should have been done. After all, he simply ran an auto parts and ambulance company. Harry called the prosecutor. Jones was becoming very good at calming Harry down.

The next day, County Prosecutor R. DeWitt Jones ordered an exhumation of JoAnn's body, which had been buried only a week before. The body, as it turned out, did not have to be completely exhumed. They uncovered the top half of the coffin and took the prints from her hands in the grave.

When Diamond got to his office, the information on the license plate number was on his desk. The car belonged to Grant Wilson in Camas—the same Grant Wilson whose Oregon plates had been found by the two women searching on their own.

Harry didn't like coincidences.

The tan Pontiac belonged to Grant Wilson. Grant also owned a black Buick and was the owner of the discarded Oregon plates. They weren't sure how the Pontiac fit, but it was a lead. Harry again called the Portland detectives. From them, he learned that in addition to Glenn and Rassie, there was yet another brother with a criminal record. Portland detectives William Brian and Mike O'Leary had arrested Utah Wilson early in 1948 for burglary. He had received a two-year sentence in the county jail, but he had been released in November with time off for good behavior. One month later, he had married Lucille.

The detectives also knew Grant Wilson. Harry learned that Grant was the only brother who had never been arrested. He was a devout member of the Assemblies of God and had a job, a home and a family. The detectives doubted that Grant would be involved. Harry did not doubt the detectives' opinion, but the coincidence of the two cars and the license plate had to be resolved. He and Sheriff Anderson drove to Camas.

Grant Wilson was an introspective man who carried himself with a serious, almost stern appearance. He readily admitted to owning the two vehicles, the Buick and the Pontiac. However, he maintained silence when asked the serious questions, like how the Pontiac happened to be in Portland, if he could explain the blood and the broken tooth and the button, where he had been on the night of March 19 and where his brothers Utah and Turman were. He sat silent and still.

Then, heaving a deep sigh, he said, "Gentlemen, I have a great decision to make. May I talk to my pastor before answering your questions?"

Reverend Ralph Cranston responded to Grant's call. The chief and the sheriff waited while the two men talked, Grant seated with his head down and Cranston in a chair in front of him, leaning forward. Reverend Cranston counseled Grant that his duty was to tell the truth—that whatever came after that was God's will. Finally, with Cranston by his side, he returned to the two lawmen.

"I am ready to answer your questions. My duty was not clear before, but I know now that God's will be done." The pastor stayed by Grant's side as he told his story. The two brothers had been free to use his cars whenever they liked. The night of the kidnapping, they were driving his black Buick.

On Monday, they came to him and said that they had read the news of the kidnapping and felt that because of their records the police would be looking for them. They both decided that it would be best to leave the state. Grant asked them directly if they had kidnapped the girl. They both denied the crime and said that they had never seen her.

Grant drove his two brothers to Portland, where they bought a 1938 Oldsmobile using the alias Ted E. Davis. He said that he did not know where his brothers were. They had arranged for the title on the Oldsmobile to be sent to him in Camas, and then he was to forward it on to the brothers. He did not know how the Pontiac came to be in Portland and could not explain the blood, the broken tooth or the button.

The Buick was impounded, and the chief drove it back to Vancouver. On the way, he noticed that the exhaust pipes were broken. The back seat filled with exhaust fumes.

When Harry walked into the police station, Detectives Borgan and Ulmer were waiting for him with news. The print on the beer bottle matched Utah's prints! Another set of Utah's prints was in the Pontiac, but it was, after all, his brother's car, so no inferences could be made from that. But his prints were on the bottle.

Diamond sent the two detectives to Camas with orders to stay with Grant, as the brothers were certain to get in touch with him. They did indeed call and soon. The story was emblazoned across newspapers' front pages. Pictures of the Wilson brothers dominated the news. They were old photos, taken almost ten years before. People remarked on how nice looking they were. One looked a little like George Raft.

Harry Diamond and Detectives Ulmer and Glen Anguish had worked nonstop for forty-eight hours. They looked tired to reporters, and they were. On March 29, County Prosecutor R. DeWitt Jones said that they had worked night and day without breaks. He said, referring to criticism in newspaper editorials and by Portland police, "This should be the point where criticism stops. It is not fair play."

"Through the tireless efforts of the Vancouver police department, we have developed what I believe to be a very strong prima facie case against Turman and Utah Wilson," Jones added. "There was no evidence that these men were seeking this particular girl. It is believed that they were waiting for nurses to come out of the hospital that night. This girl happened to be a victim because she came along at the time they were seeking a victim, we believe."

No one could have known in advance that JoAnn would miss her bus. No one could have known that there was no one to come to Vancouver and fetch

her home. No one could have known which route she would choose to walk from the bus depot to the hospital.

The newspapers were already beginning to discuss the animosity growing between the two law enforcement agencies. Although Chief Diamond did not publicly voice his frustrations with Sheriff Anderson, reporters were noticing occasional barbs thrown by Diamond. The newspapers were also editorializing about the actions of the sheriff at the Cusic home. Across the Pacific Northwest, critical articles appeared.

The *Vancouver Columbian* newspaper editorial on March 30 read:

> *The Columbian has expressed its low opinion of the way in which the various law enforcement agencies handled the JoAnn Dewey case at the outset.*
>
> *But the vital thing at the present moment is the capture the criminals. A warrant has been issued for the arrest of two suspects. The utmost cooperation is needed to bring about their apprehension.*
>
> *And it will have to be a different kind of "coordination" or "cooperation" than was shown last Sunday morning when the sheriff and his deputies sneaked up to Carson without notifying the city police or state patrol that a body (which proved to be JoAnn's) had been found.*
>
> *The brutal and disgraceful way in which the Cusic home at Battle Ground was "invaded" is another instance of the ineptness that has cropped up at various times.*
>
> *When JoAnn's slayers are brought to justice—as they surely will—there will also have to be some accounting given by those entrusted with the prevention of such crimes. This is a case that the public will not soon forget.*

The misdeeds of Sheriff Anderson, with the exception of the episode at the Cusic home, could be laid to his inexperience. This crime was bigger than anything he had anticipated when he accepted the appointment to the office just months before. The crime had become national news.

Now, a nationwide alert was sent out for the arrests of Utah and Turman Wilson, under suspicion for the kidnapping and brutal murder of JoAnn Dewey. The 1938 Oldsmobile and its license were included. A request was sent to the Federal Bureau of Investigation asking for its assistance. Bulletins were sent to California and especially to Sacramento. Deputy Ed Scott of the Marion County Sheriff's Office reported seeing the brothers in Silverton and drinking in a bar in Detroit, Oregon, the day before the crime. Police in Silverton searched at their father's home for

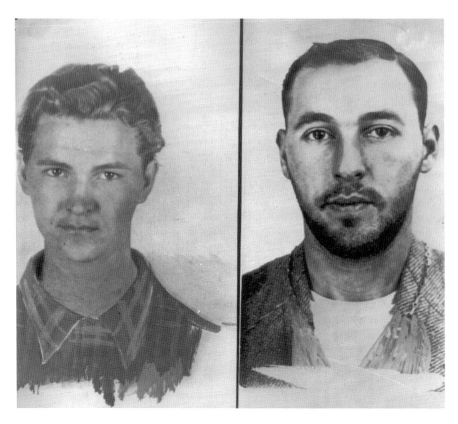

While the search for the Wilson brothers was underway, the images of the two men were doctored somewhat. Utah appears even more schoolboyish, while Turman's beard is darkened. *Author's collection.*

the 1938 Oldsmobile, registered in Silverton at the home of their father. A California agricultural officer manning a border checkpoint reported that the car had crossed the state line on Tuesday. More information was sent to California.

Public unease was growing in Vancouver. A woman who worked at the Spic and Span drive-in restaurant downtown told her boss that on the night of the kidnapping, she saw two men in a car with a woman. She said that they had stopped for food.

The manager called the sheriff. She repeated the story. Later, she called to police to report that she was followed by a man who pushed something in her back and told her to look straight ahead. He threatened her. He said that if she told what she knew about the case, she'd be killed. She said that he told her to leave town within twenty-four hours.

The records room at the police station never closed. Harry Diamond stands with his back to the camera. *Richard Grafton Collection.*

She called again: a dark car, she didn't know the make, was parked outside her apartment. Two men loitered about the car. They were of dark complexion. She hadn't gotten a license number. The next day, she called again: a man had leaped out of her closet and tried to strangle her. She checked herself in at St. Joseph's Hospital. Chief Diamond met her there. He then went to her apartment and found that there were no signs of a struggle. "Not a thing was disturbed." He added that he was "not discounting her story, but there is nothing to indicate a major development."

Then, what the police had been waiting for finally happened. Turman called Grant to see if the police had been to see him. He told Grant that they were in Sacramento, and he'd be mailing contact information. Grant asked the detectives to give him two days to talk his brothers into returning to Washington. They agreed to that condition. Then he told the detectives where his brothers were, somewhere in Sacramento.

Chief Diamond was not going to give the fugitives two days or even a single day. Bulletins were sent to all the agencies in the Sacramento area. All they could do now was wait. Each time the telephone rang, they'd leap to answer it. The report room was getting stuffy. They waited for the next call.

AN UNEVENTFUL ARREST

The bulletin from Vancouver was read and displayed in Sacramento and its surrounding suburbs in Central California. The California Highway Patrol received the information with the description of the two-tone blue 1938 Oldsmobile.

Sacramento officers James Hansen and Nick Surgan left the police station working the day shift. Just six blocks from the station, they spotted the Oldsmobile parked at the side of the street. There was an overcoat draped over the front seat, which indicated that the car had not been abandoned.

They reported the find and backed off to watch the car while the FBI and Sacramento detectives organized. A car of detectives and FBI agents watched the vehicle from a half block away. Two more teams waited in a garage with a clear view of the car. They waited for more than two and a half hours.

At 6:55 p.m., they were alerted as two men wearing dungarees and sport shirts walked together down the street toward the car. All teams moved quietly forward as Turman and Utah approached the car. The Wilsons gave up without a struggle. When asked for their names, they identified themselves promptly with no discussion. Utah was carrying a Spanish .25-caliber Llama automatic pistol. Turman was unarmed, but there was a .38-caliber six-shot revolver under the front seat of the car under the overcoat.

Turman said that he knew what it was about: "Anytime something happens up there they blame it on me."

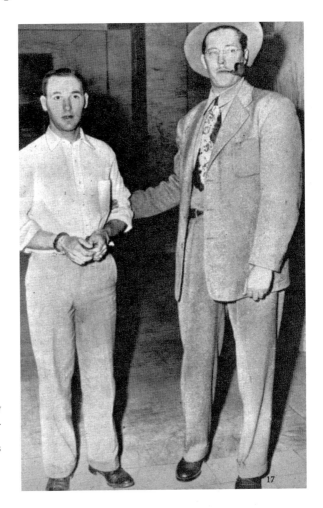

Turman Wilson in custody in Sacramento, California. He's handcuffed to FBI Agent Guy Tull. Turman's diminutive stature makes Tull look like a giant. *Washington State Archives.*

Sacramento detective Robert E. Doyle told the press that the brothers denied any involvement in the murder. He added that Utah was carrying $550 in $10 bills. Utah told him that it was cash he had taken in the burglary that landed him in the state reformatory. "The money is mine," Utah declared. "I earned it doing time in prison."

A search of their motel room revealed a complete set of newspaper clippings about the murder. Doyle called Sheriff Anderson, who told him that he and one of his detectives would immediately come to Sacramento. The sheriff had a problem, though, since that was during the time when he himself was facing charges for the Colin Cree incident. He posted bond with the court guaranteeing his return. He did remember to notify Chief Diamond this time.

When a reporter asked Chief Diamond if he would be sending someone along to Sacramento, in a somewhat sarcastic tone, he replied, "If we're invited, we'll probably send someone from the department along." Diamond was still smarting over the public comments of Portland police captain William Brown, who accused the Vancouver Police Department as well as the Sheriff's Department of bungling the investigation.

Detective Brown felt that they should have picked up the Wilson brothers immediately—he had warned the Sheriff's Department about the Wilsons. He was scathing in his remarks about the failure to fingerprint JoAnn. He added that he'd asked the Sheriff's Department to pick up and hold Utah some weeks earlier on suspicion of robbery, and it had neglected to do it. Brown included the Vancouver police in his statement.

Now Diamond seethed. He had, however, already dispatched Detectives Ulmer and Borgan on the night plane to Sacramento. The next day, April 1, 1950, two vehicles left Vancouver, with Chief Diamond in one and Sheriff Anderson in the other. A team of detectives accompanied them. They carried leg chains, intending to bring the brothers back, one in each car. Eunice Wilson, their mother, pleaded in the newspapers to bring her boys home quickly. She said that she feared that they would get "the third degree" if they stayed in California.

The brothers were arraigned before U.S. Commissioner Adele McCabe on federal charges of flight across a state line to avoid prosecution. Their bond was set at $25,999 each. McCabe told them that the United States was prepared to drop the charges of unlawful flight if they would waive extradition. Utah immediately waived extradition. Turman refused until he could talk to an attorney. He spoke on the phone with an attorney named Bramley. He told the Wilsons that their fight was not in Sacramento but in Clark County. That it would be better to save their money and waive extradition. They spoke to other attorneys and soon realized that Bramley was right. The brothers waived extradition, so the federal charges against them were dropped. Then the Clark County warrant was served, and the two were taken into custody by the Washington officers.

The next day, April 3, 1950, in shackles, one in each car, they departed on their return trip to Vancouver. It was a clear, warm day, with a full moon that would rise at eight o'clock that night as they drove north. The first night, the brothers were locked up in Klamath Falls, Oregon. The next morning, Sheriff Anderson received a radio message that there was a crowd of about one hundred people milling around in the street by the jail. They were apprehensive for the brothers' safety. Local newspapers discounted this

The Wilson brothers as they appeared during the first of many news conferences. Here they are clad in jail overalls as they give their story to reporters. *From the* Vancouver Columbian.

story. They said the people gathered at the jail were just reporters and the family of the Wilsons. An *Oregon Journal* reporter wrote, "One old man, a few curious youngsters on bicycles constituted the crowd." Harry Diamond, however, believed the police superstition about a full moon. Anything could go bad under a full moon.

They decided that it would be better to take a circuitous route into the city. Rather than drive across the Interstate Bridge from Portland directly to the city, they drove east to the Bridge of the Gods at Cascade Locks, Oregon, four miles upstream from Bonneville Dam. This route took then past Eunice

Wilson's home. Utah asked the officers to radio ahead to let their mother know that they were all right. She would be waiting at the courthouse. They radioed that message.

The group stopped at the Bridge of the Gods Café for lunch. During conversation, Utah told Anderson that in the early morning hours of March 20, he and his brother had noticed two black Pontiacs parked near his mother's house. They said that were sure they were police cars and that Utah would be picked up for the stolen power saw. Anderson didn't know why there would be police cars there. Harry Diamond reminded the sheriff that Vancouver police only patrolled in the city limits.

After lunch, they stopped at the Wind River to view the site where JoAnn had been found. Neither brother said a word.

Instead of heading directly to Vancouver, the two teams drove into Kelso, a city forty miles to the north, in Cowlitz County. Utah told a reporter from the *Oregon Journal* that "one jail is as good as another." The sheriff, C.W. Reynolds, bought Turman a pack of cigarettes, and he found a detective story magazine to occupy his time. Then he suddenly "exploded," according to Reynolds, saying that he was not guilty and would "sue everyone connected with linking me with the case."

The next day, they continued on to Vancouver. The two vehicles entered the underground garage that led to the jail. As soon as the doors closed, they were whisked upstairs into their cells, and both were given standard white coveralls. There the two told reporters that they had been treated well by both local and Sacramento officers.

Handling the prosecution would be R. DeWitt Jones, assisted by Don Blair, deputy prosecutor, and Raymond, Skamania County prosecutor/coroner. Turman called on Irvin Goodman, who was a top attorney in Portland and who had represented Turman in his robbery charge. He had gotten the possible ten years to life reduced to eighteen months. It is not surprising that Turman would call on him again.

Under Washington law, an attorney from another state may only assist; the lead attorney must be local. Sanford Clement from Vancouver was appointed as the brothers' defense attorney. Judge Eugene Cushing approved the arrangement.

On Thursday, April 20, 1950, just one month after the crime, the Wilsons appeared before Clark County Superior Court judge Charles Hall for arraignment. Both pled not guilty to kidnap and to first-degree murder. The judge fixed bail at $25,000 each. Neither could make bail. Trial was set for June 12, 1950, before Judge Eugene C. Cushing Jr.

Utah and Turman Wilson arrived in Vancouver on June 12, 1950, after spending a night in the jail at Kelso, Washington. The officers in this photo are not identified. *Luse Family Collection.*

 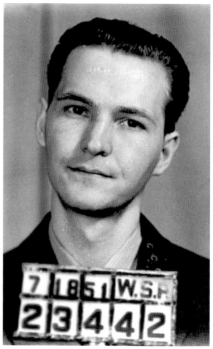

Left: Turman Wilson's mug shot from the Washington State Penitentiary at Walla Walla; *Right:* Utah as he appeared when he was booked into the state prison system. Turman had always tried to protect Utah from the system. *Washington State Archives.*

Goodman closeted himself with the brothers for hours. He talked for five hours with Turman and another five with Utah the next day. They told him the story of the stolen power saw. Logging and lumbering sites on Larch Mountain were queried. No one had reported a stolen power saw. No one had heard rumors of a stolen power saw. Logging sites across the county were queried; again, there were no reports.

The Assembly of God minister Ralph Cranston asked to be included in the interviews. The sheriff refused. Goodman asked that the minister be included. This time, the sheriff relented. Goodman told the sheriff that that the men had answered every question fully without hesitation. Then he asked that the brothers be permitted to share a cell, that being alone made their days long and dreary. They were used to being surrounded by siblings. Could that concession be made?

The sheriff agreed to put the boys in the same cell, as it had given him an idea. An unfortunate idea, it would prove.

THE RECORDINGS

Sheriff Anderson came up with a plan to install a recorder in the cell in which he'd lock the Wilsons. It was legal; there was as yet no law against it. On April 14, 1950, Anderson installed a Webster microphone in an electrical outlet box on the south wall of a women's jail cell that shared a wall with the matron's office. The wire was connected to a Webster wire recorder. There were headphones connected to the wire recorder.

Goodman was pleased to have the brothers united. It would make his interviews easier and more efficient. He visited with the brothers in the cell. Utah and Turman were then left alone. Goodman was concerned that the cell might be bugged. He wrote all his questions to the brothers. When Utah began to read the answers aloud, Goodman warned them that the "walls might have ears." He told them to write their answers.

Meanwhile, Sergeant Claude Cross of the Oregon State Police and Don Blair, assistant prosecuting attorney, entered the apartment next to the cell and recorded and monitored the conversations. Sheriff Anderson joined them. At 5:45 p.m., Turman was returned to his own cell. The wire spools were transferred to sixteen-inch discs.

The first recording, that of the meeting of the two brothers, was dramatic. There were several minutes of silence and then low chuckling. Then Turman asked Utah how much he told the "dicks." He spent several minutes lecturing Utah on how much the state had to prove for first-degree murder. The sheriff would remark that he'd gotten his education in the penitentiary. Utah started off, quite plainly:

Utah: "They got the bottle, they got the car, they got the body, why'd you have to kill her?"

Turman: "...had to kill her, she knew too much....If you hadn't been drinking that beer we wouldn't have been in the fix we are....The rubber he's wearing...that's all...let's dick her...both...left foot out...purt' near scared me too...put her in...robbery [?]...watched her...Portland."

Utah: "I wish you had-a buried her with the rest of the stuff."

Turman: "Well I do too, I wish we'd lost that...47...Ford with...Coover in it....The fuckers came down the God Dam road...I could see...well she said....There were three cars coming...counting Dick's 6. On top of the ridge...by the bridge next to Colby's car. Well if we'd moved our car out on the ridge road they'd picked up the fucking...right there."

Utah asked a question:

Turman: "That's right that's right."

Utah: "He said, he said, he clouted her on the head if she did float away."

Turman: "Marvin Colby is going to suffer and so are we."

Utah: "You should have told him about the body."

Turman: "That's right....Turman I knew she didn't float because I ducked her head....Didn't Leonard Coover tell you he sent her fucking clothes flying into the chute."

Utah: "You mean Colby that's what he said."

Turman: "That's what he said...chute. It wasn't on fire then was it....Colby took the back mat too....The body would have been in a God Dam culvert if it wasn't for Cranston....The first thing we know, the brother and sister wouldn't let us go."

Turman then said, "Cranston turned his head and said, 'One murder is good enough but that ain't all we saw. And he carried her across the bridge.'"

Utah: "Think she was buried? And he went off the bridge and wiped the blood all off his shoes...either one of them...three guesses take her down on that fucking bridge, that's the only thing you can do."

Then they spoke about escape.

Turman: "We're back here away from everything, we could knock a hole, or blow it up...."

On May 4, 1950, Anderson installed another microphone in an electrical outlet in a cell known as Juvenile 1. That microphone terminated in a storeroom. Detectives Anguish and Brown, along with Anderson, monitored that bug.

On May 15, yet another microphone was installed in the heating duct of the receiving cell. That was connected to a Masco recorder. Several officers from both departments monitored and recorded conversations. In all, more than two hundred hours of conversations were recorded. Transcriptions of the conversations were taken, but the recordings were never to be introduced at trial or revealed until after the verdict. Sheriff Anderson would later say that they reeked of obscenities and filth and should not be played for the public.

But names were mentioned, and for the next two months, the sheriff and his detectives tracked down every name that they could decipher. Anderson was convinced that JoAnn had been targeted by someone that she knew.

In a later transcript, Turman later said, "Colby hit her right in the chin." Then, "Give us a ride" and "Colby says this is the Sheriff."

The most provocative statement, made by Turman, was, "Jesus, I don't know who to put the blame to, it's a rough fucking setup they're trying to frame our ass. Fuck Colby running off. The main thing where is he? No kidding we want our fucking dough when we get out." A nonstop investigative search began around Marvin Colby and his connection to the Wilson brothers.

Throughout the recordings, the beer bottle comes up. On May 9, Turman said, "It wouldn't matter if they found a whole case of beer bottles. If witnesses saw that bottle fall out of the car, that would be a different story." Utah replied, "Did you see the bottle fall out of the car?" "Why sure I did," Turman snapped back.

Utah said, "A half hour before it was raining, then it was dry, they found the beer bottle in the street." Then, after a muffled comment, "I don't give a fuck if they have a whole basketful of fingerprints, if they hang me I hang." Then Utah said, "I never died much before." Turman replied, "You only die once and that's for a long time."

On June 8, Turman said, "You know God damned right you are guilty." Utah said, "If they find the fuckin' clothes they can find"—the rest of the sentence was garbled.

Turman's voice dropped, and he said, "…kicked he ass [*sic*] out of there… [garbled]…grabbed her by the left foot…to the bridge. Dropped her in… watched her." Then the sound of Utah sobbing could be heard.

During one meeting, Turman raised his voice to cry, "They're going to hang your ass and you don't even know what it's for?"

Several conversations spoke of escape, that they were back in an isolated section and could blow the walls out. One of the biggest arguments that they had was over their brother Grant and just what he had done or said to bring about their capture. Utah admired his brother greatly as the only one to lead a respectable life. Turman argued for an hour that Grant had told the police where to pick them up. He argued that Grant had done it before Grant was even convinced of their guilt.

"By God, just a minute here Tah, I phoned him on Wednesday night. Thursday we were picked up. Thursday evening they filed the fucking warrant for me. Wednesday night was when he went to see the bulls."

On one recording, Utah said, "Jones told Anderson that anything we want to give them to us."

"I'll take a saw and a machine gun," Turman answered. The brothers told a jailer that they knew there was a mic in their cell, which they had read about it in the *Columbian* on June 5. There had been a mention of tape recordings that day. Although the article was about a separate matter and did not pertain to the brothers, they were correct in their assumption.

Utah, that day, ran the zipper on his overalls up and down quickly, making a sound like a saw. A jailer quickly responded and searched him. So they were sure that the mic was there. Utah began to search. Using a spoon as a screwdriver, he removed the screen from the ventilator and discovered the microphone.

Seventy-five reels of tapes with two hundred hours of conversation had been produced. It is unsure how many of the recordings had been made after the brothers had discovered the microphone. Goodman told the press that they had withheld news of the recordings until after the jury had been sequestered. DeWitt Jones told the press that none of the recordings would be introduced in the trial, and he deplored the introduction of items into the press that were not directly connected to the trial.

On August 30, 1950, the sheriff presented a bill to the county commissioners for $1,799 to cover the cost of wiring the cell. He pointed out that they had used his own microphone from home, which he loaned free of charge, and that the cost included transferring the recordings from wire and tape to platters.

After the trial, the Wilsons demanded that the recordings be played in public. That demand was never met. However, transcripts were made available to the press. They were widely published, though heavily redacted for the profanity. Most of the recordings were indecipherable. They were a puzzle to be decoded.

THE LAWYERS

The presiding Superior Court judge was Eugene Cushing. Judge Cushing grew up in Vancouver and graduated from the University of Washington Law School in 1929. He paid his way through college playing trombone in big bands in the Seattle area.

He was elected prosecuting attorney and was in his second term when he was called to duty in World War II. He was assigned to the Judge Advocates Office. He attended the Command and General Staff School at Fort Leavenworth. He served with the 101st Airborne and then as judge advocate at the New Orleans Port of Embarkation.

While he was in New Orleans, a new second Superior Court seat was created in 1945. Cushing was notified that he had been appointed to the Superior Court bench. He replied that he was still in the army but that he'd accept the post if he could serve out his remaining military service. He was given a leave of absence from the court until his term of enlistment was up. Since he was stationed in New Orleans at the time, he was sworn in as a Clark County Superior Court judge by the Louisiana Supreme Court sitting in New Orleans.

R. DeWitt Jones was another University of Washington alumnus. He served as a deputy prosecutor under Eugene Cushing until Cushing entered the army. Jones was appointed to fill the position and then was elected in his own right. During the war years, he was, according to a colleague, Judge Robert Harris, a "one man shop."

As proof of his eloquence, a newspaper article that appeared across the nation noted that Jones, in one of his cases, had failed to convince the jury

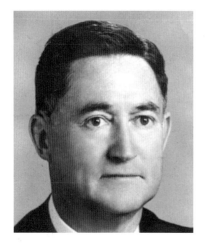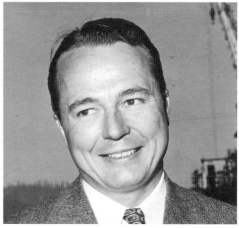

Left: Judge Eugene Cushing was so well respected that the State of Washington held off filling a new Superior Court position until he could complete his military obligation. *Clark County Superior Court.*

Right: R. DeWitt Jones was Clark County's longest-serving county prosecutor, with thirty-four years of service. He had been a deputy prosecutor under Eugene Cushing. *Emilou Jones Nelson Collection.*

of the guilt of defendant Ulysses Tate, and it could not reach a verdict. However, his summation so moved Tate that he began to weep. In tears, he changed his plea and declared himself guilty of robbing H.B. Webb at knifepoint and taking his wallet.

As the population of the county had swelled with wartime industries and military buildup at Vancouver Barracks, Jones handled not only the criminal cases of the courts but also the municipal law of the county government. He eventually did add two deputy prosecutors to assist. One of those was Donald Blair, who would assist him during the Wilsons' trial.

Irvin Goodman, the defense attorney, was a graduate of Reed College and the Northwestern College of Law, now known as Lewis and Clark. His wife, Ora, also attended that institution for a year before transferring to the University of Oregon. She was a librarian in New York's Lower East Side and then moved back to Portland's public library. She and Irvin married in 1940. She retired from the University of Oregon's Medical School library.

Goodman was by then a well-known radical attorney, serving as counsel for several persons called to testify in front of the House Un-American Activities Committee. He helped to defend Lieutenant Nicolai Redin,

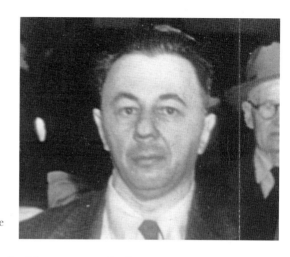

Defense attorney Irvin Goodman had never lost a capital murder case. He was confident that he would continue that streak. *Author's collection.*

a Soviet naval officer who had been accused of trying to steal American secrets. He prepared a case before the United States Supreme Court to overturn the Oregon Criminal Syndicalism statute. That statute concerned conspiracies to overthrow the government. He won that case, and the statute was overturned. In his career, he participated in twenty-eight capital murder cases. He had lost none.

Sanford Clement was the attorney of record in the Wilson case. When the brothers asked for Irvin Goodman, he was happy to agree. Goodman was famous. However, under Washington law, an out-of-state attorney must be approved by the court and could only be an associate counsel. Judge Cushing agreed and appointed Irvin Goodman as associate.

The best of two disciplines, defense and prosecution, were about to do battle.

THE INVESTIGATION
CONTINUES

Officer notebooks tally the grueling, methodical step-by-step process of the investigation that continued long after the Wilsons' arrest—as well as, in fact, throughout the trial—consisting of often fruitless searches, dead-end follow-ups and second guessing. They'd go back and retrace their steps, brainstorm and start again.

The intensive search for Marvin Colby, named in the recordings, would continue for weeks. They checked county and city files, Oregon State Police, Washington State Patrol, Multnomah County, Portland Police Bureau, the FBI, the post office, veterans organizations, the state employment office, Washington and Oregon Penitentiaries and automobile registrations. Nothing was found.

Then, success! The Oregon State Police found an operator's license that was issued to Marvin Lee Colby of Fort Lewis, Washington, Headquarters Medical Battalion. On June 9, Detectives Robert Brown and Glen Anguish, along with Deputy Scott and the sheriff, headed for Fort Lewis. Colby had been discharged just five days before. His father had a business in Alaska, and they believed that he had headed directly there.

Another soldier mentioned that Colby drove a Buick. He had wrecked it and had taken it to a garage in Portland to be repaired; he didn't know which garage. After World War II, the GI Bill entitled veterans to an education in the field of their choice, either academic or trade. Deputy Paul Markley checked with the GI Bill listings in Portland and found that there was a registered school for bodywork, Adcox School. His hunch was right.

They found that the Buick had been there. He had the license plate, and it belonged to Colby's sister. They found Colby's brother, who now had the car.

The detectives researched his movements and spoke to his sergeant, whose name happened to be Ted E. Davis, the same name that Turman had used as an alias to buy the Oldsmobile and to carry on correspondence with his father in Silverton.

They checked back with each of the friends of JoAnn's whom they had contacted: Had she ever dated a soldier? None had ever heard of that. Had she ever mentioned Marvin Colby? None had ever heard that name. At last, they located Marvin Colby, living with his mother in Elk City. Oregon State Police sergeant Avon Mayfield and Officer James Finney questioned him. He denied any participation in any murder. He was reluctant to go to Vancouver to speak to investigators there. His mother called and advised him to go. He took her advice and agreed. He was interrogated for several hours, but at 1:20 a.m., on June 11, Prosecutor Jones authorized his release, and he was placed on a bus back to Elk City. He had accounted for his time.

Now, Anderson ordered a search through files for any name that resembled Marvin Colby. His attention now turned to Marvin Coburn of Salem. He had been arrested for being drunk and for traffic violations. Officers were sent to interrogate him, his wife and his in-laws. He had not ever been away from home, he and his family stated. He did not know the Wilsons and had not been involved with them. Perhaps one of his brothers had? He did not associate much with his brothers, he said, and he had no idea of their movements.

Somewhere the Wilsons had heard the name Marvin Colby or Ted Davis. Both names are in the recordings. Ted Davis had been Colby's sergeant at Fort Lewis. Turman would be introduced to his father's landlady as Ted Davis, and that is also the name under which he bought a car, had the registration mailed to his father's house and checked into a hotel. Turman did testify that he never used his own name in any situation—he'd learned that in prison—but the coincidence seems too much.

On April 13, what appeared to be an important clue sent Deputies Cletis Luse and Singleton to the Bridge of the Gods in Skamania County. Two youngsters, Coy Bleer and his girlfriend, Sharran Chatten, parked at the turnout on the north end of the bridge. They had been there for a few minutes when a dark sedan drove up and parked behind them, its car radio blaring. The car doors opened, and by the dome light, they could see two men in the car. It was 9:30 p.m., and Sharran had to be home by 10:00 p.m.

As they left, another car drove in and parked behind the sedan. When they read of the murder, they thought it important enough to call the sheriff.

Luse and Singleton searched the turnout at the bridge and found a green ballpoint pen with the name "Wilson" scratched on it and a sheet of paper torn from a memo pad from a Shell Oil station with several names on it.

Deputies William Farrell and Robert Keenan followed up on every name on the memo pad. Finally, in the Skamania office of the Washington State Patrol, they met with Patrolman Donald Drake. He immediately recognized his handwriting on the pieces of paper and that they were from a scratch pad kept in his patrol car. He used it to make notes for his daily log. That ended that investigation.

Farrell, Scott and Keenan continued to methodically check every road and culvert in the area of Wind River. Each day, they would report that nothing had been found.

On April 17, Detectives Brown and Anguish were en route to once again check out bridges across the rivers and creeks in the area of Wind River where JoAnn's body had been found. As they passed through Camas, Anguish noticed a 1937 Chevrolet coupe; he thought it was one that had belonged to one of the Wilson family. Brown contacted one Don McPherson, who now owned the car. He had bought it from Grant Wilson. He allowed the officers to have the car taken to Camas Motors for examination. Investigators from Portland were asked to examine the car for evidence. That evidence would be used at trial.

On April 25, Deputy William Scott met Don Blair, a pilot with Sound Aviation Service, to conduct an air search of the Wind River area. It was Scott's first time in the air. Their goal was to see if there were any abandoned cars or possibly a car in the river that might be connected to the case. They left at 9:00 a.m. Scott reported that they searched all the surrounding area roads, logging roads and trails; they flew up and down the river, but could find nothing of value.

Returning to Vancouver, the engine began to sputter. At 11:05 a.m., they made a forced landing in a cow pasture five miles north of Camas. Scott concluded his report, "Due to the very expert handling of the plane it is with joy that I am able to make this report."

On May 24, R.S. Holcomb, who worked for Yellow Cab in Portland, which also rented cars, called the Sheriff's Department to advise it that the Wilsons had rented a Dodge sedan four-door, gray, after the abduction. He allowed the officers to take the vehicle for investigation. That closed a gap in the chain of switched and moved cars.

On May 25, Sheriff Anderson asked Glen Anguish of the Vancouver police to go with him to talk once again with Grant Wilson. Grant was with Reverend Cranston again, having just come from visiting his brothers. Now, however, he had been told by the boys' attorney, Irvin Goodman, not to say anything more. Anderson said it would help his brothers. Grant stolidly refused.

June 13, Marcia Babcock, a friend of JoAnn's, called to volunteer any information. She'd known JoAnn since their school days. They had triple-dated on Friday night, March 17. They'd gone to a drive-in theater and had gotten home at about 2:30 a.m. and had gotten up for work at 7:30 a.m. She gave them the names of JoAnn's boyfriends, but she'd never heard of a Marvin Colby. No, she'd gone out one time with a sailor, but never a soldier. None of JoAnn's friends remembered a soldier.

Now they looked at JoAnn's brother-in-law, Johnnie Rebisch, who worked at a restaurant on Burnside in Portland. Sometimes, JoAnn would get a ride back to Meadow Glade with him. He had had some brushes with the law, He'd dodged the draft, and he'd had several arrests for drunk and disorderly and for drunk driving. His most serious had been for embezzlement. When JoAnn was first found murdered, the Portland police had looked at him but found nothing.

Even though the trial had started, the investigation did not stop. If an informant offered any information, officers were sent to interview them. Much of what was gathered was not used in the trial. A Vincent Bunch was reported to have said that he saw Turman in a tavern in Portland. Bunch told officers that he'd known the Wilson family in and around Vancouver for about fifty years. He'd known all of the Wilson brothers since they were small children. He said that on Monday, March 20, at about 7:30 p.m., he'd seen Turman with another man at the Rosewood Tavern on Southeast Stark Street in Portland. He heard Turman remark, "We got rid of that girl in a God Damned big hurry." At these words, Bunch said, he turned around, as he recognized Turman's distinctive voice. When Turman saw Bunch, he hurriedly left the tavern. Bunch said he'd testify if called on.

Another witness, Mrs. Boone, the owner of Boone's Pine Camp on the Wind River at the Hemlock Wind River Highway, was interviewed in Stevenson on June 23, 1950. She definitely remembered Utah being there in 1946. He was with another boy, older and bigger. They asked her for a cabin but had no money. They said they were looking for work. She gave them a cabin, telling them that they could have the cabin but not to use the camp wood—they'd have to get their own wood. They did odd jobs

and hauled wood for her. Since she had given them the cabin for free, she didn't have them sign the register. She would, she said, testify to this. The officers passed this data on to the prosecutor to show knowledge of Wind River. It was not used.

Searching his files, Sheriff Anderson found a report regarding Lester Miller, who was said to have a record in a Montana reformatory. He had supposedly told his father that he had known JoAnn and had gotten her pregnant. Detective Scott drove to Carson and spoke with Lester's father. He "emphatically said he had not told him any such thing, and he did not know where this story came from." He added that Sheriff Reid had asked him the same question. He told the detective that Les and his uncle, Charles Miller, were working somewhere north of Bingen, Washington. Scott could not find anyone at Bingen. Sheriff Reed offered to help find them.

Seventh-day Adventist women in Silverton, Oregon, saw a neighbor burning some clothing that looked new. They quickly telephoned Mrs. John Olson, a Meadow Glade Adventist. She, in turn, quickly called the sheriff's office. The Oregon State Police were notified and investigated the burning clothes but found nothing untoward.

Soldier after soldier at Fort Lewis gave statements. Page after page of reports were filed. On July 6, 1950, following up on a statement deciphered in the recordings—"Colby says this is the Sheriff"—Anderson interviewed another Fort Lewis Soldier, Charles Emery. He had the nickname "the Sheriff." Anderson asked the CID to extensively interview this soldier since Emery had a scar on his right hand that might have been caused by punching someone.

A terse report by Deputy Luse shows up on July 5, 1950, after being assigned to check out Charles "Chuck" Emery Jr. He wrote, "PFC Charles Emery Jr. is a carpenter. Has been charged with crime of rape. He is 25 years of age, 5'10, 160 pounds. Medium build, brown hair, blue eyes. He is now in Jail in Portland and has been there since last November, 1949. He will be there for some time yet."

Lucille Wilson, Utah's wife, met with Deputy Cletus Luse. He had become a close friend and confidant to Lucille since her marriage to Utah. They met at the bus station on July 17, 1950, since she didn't want to go to the police station. They chatted in his car, parked by the shipyards. She told him then that she thought a man named James Cox was involved somehow. An extensive search was then carried out for James Cox.

The investigation led officers to the Louise Home for Girls, now the Albertina Kerr Center, but in 1950, it was a home for unwed mothers. They

spoke to a former girlfriend of Marvin Colby's. She said that it had been a long time since she had dated Colby. He had come to her house once with another man who drove a convertible. But she thought that he had a friend named James Cox, whose girlfriend was now also a resident at the home.

A discharged soldier named James Cox was found living in Richmond, California. A local officer was sent to the home and found a brother. His wife said that James had stayed with them for two months after his discharge and had now moved to Mountain View, California. The investigation now shifted to Santa Clara County.

Since the kidnappers had yelled out to witnesses that JoAnn was his wife, detectives checked nearby counties to see if a marriage license had been issued to her. None had. Sheriff Anderson continued the investigation throughout the trial and after it. He continued questioning soldiers at Fort Lewis. Then he moved on to Fort Ord on December 9, 1950, with Deputy Howard Hanson. They went directly to the Criminal Investigation Division. Sheriff Anderson told the press that he planned to work with CID for several days: "This isn't anything different than what has been going on for eight or nine months, and it has involved hundreds of people already. It's just a matter of more interviews, and I've already interviewed more than 200 individuals connected with the army."

In December 12, 1950, CID officers declared that a young soldier was completely cleared of suspicion. They said that he was released after extensive questioning. To protect his identity, the CID did not release his name.

Day after day, the sheriff listened to the recordings, slowing the speed, replaying, trying to decipher the noises on the tape. He sat, with the earphones on his head, desperately trying to make sense of the sounds he was hearing. If he could make out a word, he'd write it on a notepad. Perhaps other words would connect.

The ultimate challenge, the trial, interfered with the monitoring.

THE TRIAL

Superior Court judges were concerned that the trial would be lengthy. In the Clark County Courthouse, there were dormitories for jurors—one for men and one for women. There were no showers. Somehow, when the building was constructed, this necessity was overlooked. For a night or two, sponge baths would suffice, but this trial might last more than ten days. The county commissioners ordered the showers to be built and other plumbing necessities updated. It was done and finished on time. The jurors walked to restaurants downtown under the care of bailiffs.

Early Monday morning on June 12, jury selection began. The county auditor presented a list of seventy-five eligible voters. It was immediately apparent that it would not be easy. Many prospective jurors announced that they had already made up their minds as to guilt or innocence. Several were opposed to the death penalty. Many of the women who had been drawn had small children, and others were elderly, partially deaf or in ill health. Several were farmers who had milk cows who had to be milked twice a day. It was mid-June in a farming county—work had to be done.

They soon used up the original venire, and they still had not filled the jury box. An additional seventy-five names were drawn. The starting date of the trial was approaching. They were down to just one potential juror. They needed two. Then a juror fell ill and had to be excused.

Judge Cushing sent two deputy sheriffs, Albert Swick and Charles Singer, out into the street to find six more jurors. They soon returned with six men in custody. They'd rounded them up on Franklin Street in front of

The Clark County Courthouse had opened in November 1941. The jail was on the fifth floor. The courtrooms were on the eighth. *Author's collection.*

the courthouse. With that hapless half dozen, a jury of eight men and four women along with two alternates was seated.

The court adjourned for lunch, afterward, the jurors were taken to Twelfth and D Streets to the scene of the abduction. It was a beautiful June day—seventy-three degrees, and the sun was shining. The Columbia River was rising with the annual spring freshet. There were fears that a flood might interrupt the trial. Fortunately, the flood quickly subsided.

As the jurors surveyed the abduction scene, reporters attempted to photograph them. They were shooed away by a deputy. Some of the jurors laughed. They did not laugh the next day when the newspaper printed their names, addresses and the names of their family members. For the men, they also printed their places of employment. The four women were all listed as "housewives"; however, their husband's places of employment were reported.

Judge Cushing ordered ropes strung in the corridor outside the courtroom to maintain order among the crushing throng that tried to get into the courtroom.

Opening arguments by the prosecution began at 3:00 p.m. R. DeWitt Jones presented his opening statement: He told the jury that the Wilsons, both violent felons, had abducted JoAnn with the intention of raping her. She was beaten, sexually assaulted and stuffed into a car with a defective exhaust system. She was dead within an hour of the kidnapping. After disposing of the body in the Wind River, they went into hiding to avoid questioning. When JoAnn's body was found, they fled to California. A beer bottle bearing Utah's fingerprints was found at the scene, putting the brothers at that place at that time.

His first witnesses were those who had been at the scene. Ann Sherbloom, a nurse in the pediatrics ward at St. Joseph's Hospital, told the court about "just the most terribly blood-curdling screams I ever heard in my life." She saw a man and woman struggling back and forth. At first just one man and then another joined him. She didn't know where he came from. Then "one of my patients cried, one of the little ones. And when I came back the car was gone. I did see that the girl was putting up the fight of her life." A nursing student, Mable Burris testified to much the same.

Irvin Goodman cross-examined each carefully. He established the actual time of the kidnapping as between 11:25 p.m. and 11:45 p.m.

Anna Dewey, JoAnn's mother, broke down momentarily during her testimony that day. She had answered all questions calmly in a firm voice until Jones places JoAnn's little possessions before her. Tears swelled in her eyes as she looked at the strap from JoAnn's purse that had been found at the scene. "Yes, my son fixed if for her just the week before." The little barrette was next. She nodded. "She had two of them."

Goodman said he would make no objection to admitting the girl's items as evidence; he declined to cross-examine Anna.

The officers who'd answered the original call were next. They recounted receiving the call and the preliminary interviews with the witnesses.

The jury was then excused by Judge Cushing while he handled a

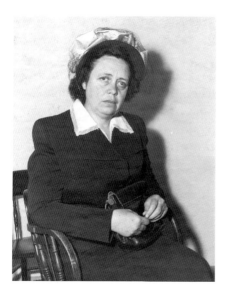

Anna Dewey's heartbreak is evident as she rests after testifying. She and her husband left town during the remainder of the trial. *From the* Vancouver Columbian.

dispute between the opposing attorneys. Detective Jason Ulmer had been testifying about fingerprinting the bottle. Goodman's cross-examination was about Ulmer's trip to Sacramento with the chief of police to pick up the Wilsons. Jones objected, saying that Goodman's questions were beyond the scope of cross-examination. Goodman waived further examination.

Ulmer continued after the jury returned. In Sacramento, he had interviewed Utah, who had related the story of the power saw as his reason for leaving Washington State.

Mrs. Stacie Goodman, no relation to Irvin Goodman, was next. She testified about the time she first met the brothers under fictitious names. She was the owner of the property where Mose Wilson rented a trailer. She had seen them the first time when they came to visit their father, on March 13 or 15. Turman was driving a black sedan, and on another visit, March 27, they were in a blue coupe. She was introduced, by their father, first to Turman as Ted Davis and then to Utah as Bob Olson. Mose was using the name Billy.

At the end of her testimony, Mrs. Goodman asked the judge if she could shake hands with the two men. The judge nodded. She was a large, strapping farm woman. With a strut, she left the courtroom, pausing long enough to shake the hand of each defendant. At the courtroom door, she stopped, turned and asked the court how she would get paid for her time away from the strawberry field: "I missed a day's mighty good picking. I could have earned twelve dollars in strawberries!" R. DeWitt Jones promised her that she would get witness fees.

Officer Frank Irvin, who was with Sergeant C.A. Forsbeck when the beer bottle was found, underwent a grueling hour-long cross-examination about the bottle. The photographs of the bottle taken that night show an Olympia stubby-necked bottle, and the written reports describe an Olympia bottle; some newspapers reported it as a Rainier bottle. Jones objected to those questions, saying that the officers had no control over what newspapers report.

Policewoman Irene Borden testified only that she had seen Forsbeck find the bottle. Goodman had no further questions for her.

County Commissioner Clarence Bone told his story—the screams, how he ran outside and what he had seen. Goodman queried whether he had described the car as a Chevrolet. He replied, "As a mechanic I'm very poor. I hardly know one make from another."

On June 16, *Vancouver Tribune* reporter John Carleton Myers was struck by the bizarre nature of the crime and trial. His headline read, "Wilson Trial Facsimile of Celluloid Thriller Macabre Details Bared." The subhead read,

"Sensational Events Rival Hollywood Colossal." Judge Cushing was furious. He barred Myers from the press box for the remainder of the trial. Myers protested, asking if there was indeed freedom of the press. The decision stayed, and he sat with the audience for the remainder of the trial.

Grant Wilson was called by the prosecution; he would also be called by the defense. For three hours, he spoke, outlining the movements of his brothers and him. He felt that the police had broken an agreement. He asked them to let him talk to his brothers for two days to try to talk them into returning to Vancouver. Instead, they had notified Sacramento, and the brothers were arrested. He was visibly weary after three hours of examination and cross-examination.

"Why so many cars?" Jones asked. The brothers obviously had keys to several of them. They had them at their disposal. Grant explained that the cars actually had been bought and paid for by Turman and Utah. With their criminal records, they could not get insurance. Because of that, all of the cars were in his name and under his insurance. He had, he admitted, told the officers half-truths when they had come to talk to him. Then his conscience began to bother him. He drove to see Gladys Cline, Utah's mother-in-law. He told her to say nothing to police until he'd had a chance to talk to his pastor.

Again, he emphasized, because of his brothers' records, they were afraid of being blamed for JoAnn's disappearance. He had again, the next morning, gone to his mother's house to see if the police had been there. Then he drove to Lackamas Lake, where Turman and Utah had been camping. They awaited him at the side of the road. For about forty minutes, he said, he'd talked to them, asking if they wanted him to intercede with the police for them. No, they did not want that. "If you're wanted by the police, don't go to them, let them come to you," Utah said.

Grant said that he next met Lucille walking toward his home. The brothers wanted to see her. The two drove to Mount Norway Cemetery, where they met the pair at the entrance. The brothers had the newspapers with stories of the abduction.

R. DeWitt Jones went over again the switching of cars, the renting and the buying. He brought out that Turman had paid for the Oldsmobile with cash. Utah had bought a car with cash. Grant's testimony became halting. He lowered his eyes as he talked of realizing that the police were looking for a black Buick and that it might be good for the brothers to keep out of sight for a while and hide the car. He repeated his belief in his brothers' innocence. Again and again, his testimony was interrupted by objections—and it would

Members of the Wilson family wait in the corridor of the courthouse during the trial. *From left to right:* Lucille Wilson, Utah's wife; Hazel Wilson, Grant's wife; Eunice Wilson, the mother of the suspects; and Grant Wilson, the brother who'd turned them in. *From the* Vancouver Columbian.

be each time he testified. That was because of the odd happenstance of being called as a witness by both sides.

Yet another car was introduced: a Chevrolet that had been parked in front of his house. Grant said that it didn't run, as it had a flat tire. He'd made up his mind to sell it because he had no use for it. He'd gotten it running and sold it to a friend of his brother-in-law's. The idea of yet another car should have come as a surprise, but the dizzying switches from car to car to rental car to buying yet another car had wearied the jury so much that another car produced very little reaction.

Portland detective Robert Brown testified about hairs found in the trunk of the Chevrolet that were the same type as JoAnn's. The seat cover had been cut out with a sharp instrument, he said, and the seat covers as he found them were shiny and slick. The trunk had been cleaned and oiled, he added, but the hairs had adhered to the sides of the trunk. The pathologist who followed Brown corroborated that testimony and said the hairs were three to four inches long, as were JoAnn's.

The three-hour ordeal ended with the last questions from Prosecutor Jones. Had Grant ever fished the Wind River with his brothers? He had, many years ago. He had never fished the White Salmon River. He was at last excused but would be called again by the defense.

On June 17, the morning was taken up by three witnesses. Guy Tull, an FBI agent, was first. He related the conflicting stories that the brothers had given. He said that Utah told him and others that he, Lucille and Turman had been fishing "up and down" the Columbia River from March 18 until March 25. Turman, however, told them that Utah was present when the Oldsmobile was purchased in Portland on March 22 but that he "hadn't seen much of Utah for several days prior to that." Turman had also claimed that he'd worked every day at his job in the woolen mills through March 24. He said that when he interviewed Utah, Utah had said that he left Washington because he'd heard that a power saw had been stolen and that he was a suspect. He left, he said, for fear his parole would be broken by that suspicion.

A second FBI agent, James F. Tanner, next took the stand. He told much the same story but added that the Wilsons had registered at a Sacramento hotel with fictitious names and only revealed their identities after their arrest. A Sacramento police officer, Robert E. Doyle, told of the arrest on the street near the Governor's Mansion. Goodman did succeed in keeping out of the record testimony about the brothers having been armed. That would have, in effect, accused them of another crime, as ex-convicts are prohibited from having guns.

Clarence and Martha Fisher, the owners of the Morrison Hotel in Portland, identified Utah and Turman as the men who checked into their establishment on the night of March 20. They said that the two men gave no indication that they knew each other, and Turman had used the name Ted Davis. Clarence walked Turman to his room, he said, and had remarked, "A big room for a big man!" referring to Turman's diminutive stature. It was not until the next morning, when Mr. Fisher went up to Utah's room to see if they'd be staying another night and saw Turman walk out of the room, that he knew they were acquainted.

Both Clarence and Martha went to the Clark County Jail, they testified, and both identified Utah and Turman as the men who had registered at their hotel, Utah under the name U.E. Wilson and Turman as Ted E. Davis. Both Fishers, when asked if they knew the location of the Playhouse Movie Theater, responded that it was diagonally across from their hotel at 1330 Morrison.

Harry Diamond was the next witness. He testified that he had taken Mrs. James Nelson, a resident of the Central Court Apartments, to the jail. Mrs. Nelson was one of the witnesses to the abduction. She viewed two lineups of six men each. Of each group of six, she stated that the physical appearance and mannerisms of Utah in one lineup, and Turman in the other, matched the men she saw. Goodman objected, saying that Mrs. Nelson had not positively identified either man. His objection was overruled. Cushing ruled that she had not intended to positively identify either man—simply their appearances and mannerisms.

Continuing his testimony, Diamond said that on the road trip back from Sacramento, Utah was obviously under great emotional stress. At one point, he broke down and sobbed. However, he had refused to answer any questions about his whereabouts or actions from March 19. He said that on that return trip, they'd taken Utah to the Wind River and walked down to the footbridge. During that time, Utah refused to look at the river, staring at the floorboards of the car or at the ground.

Goodman expressed amazement that five officers had been sent to California to bring back two prisoners. He cross-examined Diamond extensively on the lineup. Were the subjects of varied sizes? Why were the same number of people in both lineups? Were the subjects chosen at random? Diamond repeatedly answered that it was in the county jail, so Sheriff Anderson was in charge and made all the arrangements. To another question by Goodman, Diamond said that Turman had refused to answer or to sign the extradition papers at first, but after they spoke with their attorney, they did waive extradition.

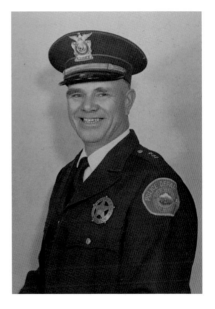

Harry Diamond, Vancouver's longest-serving police chief at seventeen years. *Greater Vancouver Chamber of Commerce.*

Goodman was expecting Sheriff Earl Anderson next. He had a list of questions for cross-examination. To his consternation, the prosecutor did not call the sheriff.

Deputy Paul Markley was next, just before the lunch break. He was asked first if he'd seen Utah on March 14.

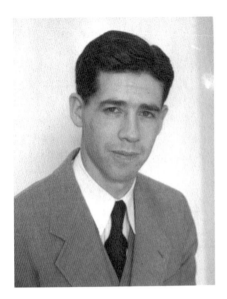

Dr. Howard L. Richardson, a pathologist from the University of Oregon Medical School, performed the autopsy on JoAnn's body. *University of Oregon.*

He answered with the story of Utah coming to the sheriff's station with his wife to bring the sturgeon to Deputy Cletis Luse. Goodman objected to the answer. He was overruled.

The worst of the ordeal for the Dewey family was to unfold next, as the pathologist Howard Richardson took the stand. His testimony was accompanied by graphic photographs of her body, the wounds, her genitalia and microscopic slides. Examination showed that the sodomy had taken place after her death. "The peculiar part about the skin," he testified, "is that the so-called goose pimples were still present on the flesh. This would indicate to me the rapid cooling of the body." In the open air, the cooling would take an average of twelve hours, he opined, but the water in the Wind River was so cold that it was as if the girl's body had been refrigerated. There was no decomposition in her body.

Anna Dewey gasped as the pictures were presented, but she regained he composure and remained in the courtroom, dropping her head and casting her eyes downward.

Looking at the food in JoAnn's stomach, the meat substitute that was only served in the sanatorium where she worked and knowing at what time that meal was served, all of it showed him that she had eaten her last meal at 7:30 p.m. That fixed her time of death between 11:15 p.m. and 1:30 a.m.

The testimony continued as JoAnn's family struggled to keep their composure. The wounds that she suffered before death included multiple lacerations under the prominence of her chin and a crescent-shaped wound behind her ear that had dripped blood. Her mouth was cut, and several teeth were fractured, with one knocked out completely.

Other gashes occurred after death. There was no skull fracture. The lack of broken bones meant that she had not been thrown off the 220-foot-high bridge, as many surmised, but were consistent with her body being thrown off the low bridge. This was important. A car could have driven onto the

high bridge to dispose of the body. Accessing the low bridge, which was out of sight of the road, meant someone had a knowledge of the area.

The mottled skin indicative of carbon monoxide poisoning was not noticed at first under the fluorescent lights, but laboratory tests showed the toxin in her blood. Jones asked if the two small areas of hemorrhage in her brain could have caused unconsciousness. Richardson said that it would not have taken much more than that, but to say for certain whether she was conscious or unconscious at the time of asphyxiation would be hard to prove.

On cross-examination, Goodman elicited the fact that while hairs from the Chevrolet resembled JoAnn's, the hairs from the Buick did not. Bailiffs mercifully led JoAnn's mother out of the courtroom.

A letter was introduced into evidence along with six slips of paper dated March 29, 1950, and addressed to Ted Davis, Silverton, Oregon. The envelope bore a Sacramento postmark of March 30. A typewritten note on the face of the envelope read, "Try the Clark County Jail." There was a ten-dollar bill enclosed with the letter. The letter read:

> *Hi Ted—I thought I would drop you a line to let you know everything is just fine here. How are things with you? If you get any mail from Grant forward it to me and don't answer his letters. Always send my letters by air mail to address I give. Those clothes—ship them by express freight C.O.D. to Mr. Ted E. Davis Sacramento, Be sure and destroy this letter. Now, send my mail to general delivery, Ted E. Davis Sacramento Cal. So long for now. Take it easy, Ted.*

The six slips of paper submitted with the letter were orders for items such as cigarettes, candy and similar goods in the jail. Deputy J.M. Hanson, the chief jailer, identified the six slips as having been written by Turman Wilson. Max L. Alford of the Oregon State Patrol was a recognized expert on handwriting. He testified that the handwriting on the receipts and on the letter was done by the same person.

Three employees of the woolen mill at Washougal testified: Leona Christopher, Harvey Hoots and Charles Haglund. Turman had been employed there. They all agreed that he had been a good employee; his top pay was $1.20 per hour. The thousands of dollars he'd left in his mother's keeping, the money to buy expensive suits and the cash for multiple cars did not come from the mill.

The jury was left to wonder: what was the source of the thousands of dollars the brothers spent so lavishly? That question was not answered in

the courtroom. Perhaps the best response was from Utah when he told the Sacramento police that he'd earned the money by doing five years in prison for stealing it.

The state rested its case on Tuesday afternoon, June 20, 1950. The jury had heard from thirty-four witnesses. The prosecution had established that Utah's prints were on the beer bottle. The beer bottle had fresh bubbles and was otherwise clean, which proved that it had been at the scene for just a few minutes. The brothers had fled the area to avoid capture. Moving the Pontiac had repeatedly showed guilt. Switching cars several times had shown the same. Conflicting stories told to different agencies showed a pattern of subterfuge. Utah and Turman were in each other's company constantly during the day of the crime. Where Utah was, Turman was.

With the jury out of the courtroom, the two attorneys argued a point of law. Goodman asked that the prosecution be required to acknowledge that the crimes were committed between the hours of 11:15 p.m. and midnight on March 19. DeWitt Jones fought that, stating that the acts that caused the girl's death started on March 19 and continued for some hours. If murder begins at a certain time and continues for some period, there is no time that can be selected by the state. Goodman countered that when the defense's proof of innocence is that he was elsewhere at the time of the crime, and witnesses have fixed the time of a crime, the state must then select the time. He added that he would consult the law books for authority.

When the jury was recalled, the judge announced that the defense's motion had been denied. Prosecutor Jones sat down at the table. Now it was up to the defense.

THE DEFENSE BEGINS

I rvin Goodman, the defense attorney, upon conclusion of the state's case, immediately moved for dismissal of the charges citing insufficient evidence and prosecutorial misconduct. Judge Cushing denied the motion. Goodman then asked for adjournment. He told the judge that he had not expected the state to rest so soon. Judge Cushing adjourned for the day. The defense began again the next morning. The basis of the defense was simply to show a convincing alibi.

Turman was the first witness called. He was to be on the stand for a day and a half. He remained cool and self-contained.

Judge Cushing told Turman as court opened not to mention anything about the power saw, as he had ruled that it could not be used since no evidence existed that a power saw from anywhere had been stolen. Therefore, he ruled, reference to the saw would be hearsay evidence and inadmissible.

Goodman was impassioned. He asserted his right to present the defense's theory and the prosecution the right to present its theory and to let the jury decide. Cushing reminded Jones that courts are run according to rules of procedure and evidence. In this business about the power saw, there was no evidence that a saw was stolen, and one cannot bring evidence on hearsay.

Even though he had been forbidden to introduce testimony about the power saw, Turman never missed an opportunity to introduce it by inference. When asked about the shifting and moving of several vehicles, Turman replied that they didn't want to remain in one place for very long. When asked why, he replied, "We had learned that Utah was wanted for

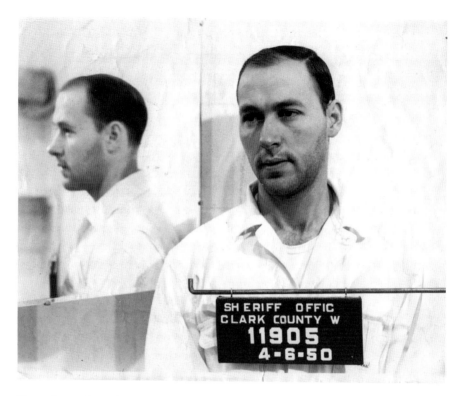

Turman's mug shot as he was booked into the Clark County Jail. *From the* Vancouver Columbian.

theft of an object that I am not allowed to mention by this court." Jones, of course, immediately objected and asked that the answer be stricken. With the jury removed, the two attorneys continued the argument that fear of being revoked on his parole over theft of the saw was at the basis of all of the brothers' movements, with Jones rejoining that no evidence had been given, nor proven to exist, that a power saw was ever stolen.

Turman continued his testimony, saying that after they left the Playhouse Theater, they stopped at Tony's Market to buy cigarettes and found it locked even though the lights were on. Goodman interrupted to ask if they were in fear. He said that he was, relating that he and his brother had been placed in a lineup in Vancouver on Friday night, but he did not know what for. Turman then said that they had starter trouble with the car and had flagged down a passing motorist to push the car to get it started. That delayed their leaving Portland by forty-five minutes to an hour, so they did not get back to Portland until 1:30 a.m. or 2:00 a.m.

When they approached their mother's house in the Green Mountain area, they saw a car parked off the road with its parking lights on. Two and a half blocks later, they saw another car parked in a service station lot. Then they saw yet another car coming down the Orchards-Camas Highway with its parking lights on. They assumed that the three cars were police cars, so they turned and proceeded to Grant's house, where they switched automobiles. Now they were driving the cream-colored Pontiac.

They did that, they said, in case they drove by the Wilson house again; they didn't want to be conspicuous. Then they drove into Vancouver, parked near Utah's house and watched to see if any police cars appeared there. Turman essentially repeated what had been said earlier regarding their movements of the next few days. About renting a car and buying a car, Goodman asked why they bought yet another automobile. Turman slipped in another reference to the saw by answering, "This goes back to the matter I'm not supposed to talk about by order of the court."

They'd again gone back to Grant's and then to their mother's home, where they picked up a thousand dollars. "That was money from his job at the mill," he added. Goodman showed him the roll of money that had been booked when they were arrested in Sacramento. "Yes, that looks like the money." The jury waited to hear the source of the money, since Turman earned just $1.20 per hour. The explanation never came.

They had wandered from Camas to Vancouver to Silverton. They left their father's house, headed for California. He said that everyone in the family knew that they were going to California. The jury appeared confused about the switched cars and the trips to Portland, Camas, Vancouver and Silverton. Goodman asked the judge to have an easel brought into the courtroom so that he could chart the movements.

Judge Cushing turned to the bailiff. The courtroom was warm and stuffy. The packed audience raised the temperature above the already warm mid-June weather.

"Mr. Bailiff," said the judge. The bailiff's eyes had been closed. "Mr. Bailiff?"

The bailiff stood. "Yes, Your Honor."

"Would you have an easel brought to the courtroom?" The bailiff strode to the doors of the courtroom, flung them open and stentoriously called, "Mr. Easel, Mr. Easel, you're wanted in the courtroom." Judge Cushing covered his mouth with his hand.

After Turman testified about his arrest and extradition from California, Goodman asked him if he'd ever known or seen JoAnn Dewey. He said

he'd never seen her nor heard of her until he read about the crime in the newspapers.

To counter the prosecution's introduction of the hairs found in the Chevrolet, Hazel Wilson, Grant's wife, testified that she had ridden in the Chevrolet in which hair samples were found. She said she'd combed her hair many times in that car. She said she'd probably pulled stray hairs from her comb and dropped them on the floor. Jones asked if she'd ever given hair samples for comparison. She had not, nor had she been asked to. Grant's daughter, who also had brown hair, had ridden in the car as well.

The defense wanted to prove that the defendants could not have stuffed JoAnn's body in the trunk of the Chevrolet and driven it to the Wind River, so the rest of the afternoon was spent in testimony that the vehicle was not running during that week. Witnesses produced a long summary of problems with that car.

On June 22, a visibly wearied Grant Wilson once again was called for the defense. His testimony began a battle of wits between the defense and the prosecution. Court watchers reveled as two highly skilled attorneys dueled. One such instance was Grant's reasons given for the cars belonging to the brothers being in his name. This was done, he had said, so that the cars could not be confiscated. He told of a time when Turman had been under arrest and the payment had not been made. The car was repossessed, and he lost the money invested in it. He added that the brothers could not get insurance because of their records, so the insurance was in Grant's name.

Under Jones's cross-examination, Grant's testimony became vague and confused. He could not remember statements that he made in his previous testimony. As to his explanations of some incidents, his testimony faltered and withered. He had said that the Pontiac was bought on February 18 with cash provided by Turman. Jones pointed out that insurance on the Buick was with Allstate. Grant said he couldn't say for sure whether it was in Turman's names. A Ford had been bought in January in Utah's name. He didn't know whether or not it was a cash transaction. Jones reminded Grant that he'd said that he sold the Chevrolet to pay for insurance on the other cars. Grant became confused, saying that the plan for buying insurance had been abandoned.

When he was asked why the Oldsmobile was bought in the name of Ted Davis, he said that the brothers knew that the other two cars were in his name. He did not elaborate on what difference that made. He said that the Buick registered to him was actually owned by Turman, and the Pontiac, also registered to him, was owned by Utah.

He described the Chevrolet as barely running, with a bad battery and a slow leak in the rear tire. He corrected several discrepancies in his testimony as to where and how the cars were parked, as well as how many keys there were and where they were kept. He said that the Buick did run well enough to drive. Looking at the jury, he said, "It would spit and sputter before taking off....I'm sure you've all had that happen." Jones objected to Grant speaking to the jury. Grant turned to the judge: "Who am I to talk to, Your Honor?" This brought a titter from the courtroom.

Grant began to have trouble phrasing his sentences. He said that Utah and Lucille had talked about a trip to Seattle to stall off the police should they want to question him about a theft. He mumbled and then stopped. He looked down. "It's hard to think, I know the reason, though. It's hard to keep my troubles straight, if I can just get started." He shook his head as though to clear it. Why had they abandoned the car in Portland? Grant explained that they planned to go and retrieve it after Utah was cleared of the problem. His last visits with his brothers had been when they found him fishing at the Camas dock and had gone home with him, and then later, on Saturday the twenty-fifth, they met on West Reserve Street by the Vancouver Barracks.

Goodman asked Grant if he'd ever seen beer bottles in Utah's home. Yes, he had, and the empties were thrown into a can in the driveway. Had he ever seen anyone removing bottles from the can after March 19? He said that he had. Around the twenty-first or twenty-second, he'd seen a man removing bottles from the can, and the man gave Grant a dirty look. He said he'd seen the same man the next day downtown near the courthouse. Had he seen beer bottles in the street around Utah's house? He had. He and Reverend Ralph Cranston had driven around the neighborhood and looked for beer bottles.

Goodman produced a brown paper bag containing two empty stubby-necked bottles in it. He asked that the package be admitted as evidence. Jones objected to the sack and contents as irrelevant, having nothing to do with the case at hand. The jury filed out as the attorneys argued the point. The bottles were found in the street and put in the sack as evidence that there were multiple bottles in the street, the defense argued. Goodman asked Grant if he'd picked up the bottles across from St. Joseph's Hospital and put them in the sack. He seemed deflated when Grant answered that, no, they were already in the sack.

All of this refers back to the finding of the beer bottles with fresh, bubbly beer. Goodman had, at that time, asked Officer Frank Irvin if he found

many beer bottles in the parking strip and other places; Irvin had answered no. Goodman then asked if he had searched the streets around the hospital after the bottle in the street was found; the officer again answered no. He had only searched the crime scene and the area immediately around it. The judge sustained the prosecution's objection to the sack of bottles, and the jury returned.

Jones zeroed in on Grant's testimony that the police swarmed around his house. When did they come to his house? "Every day" was the answer. Jones pressed on, asking for dates. Grant said he wasn't sure of dates, but they were "after him all the time."

"I want the dates," Jones said. "I want the facts and not your conclusions." Grant stuck to his story that the police came by his house every day. Later, Jones would remind him that his house was two blocks off the Evergreen Highway and on a thoroughfare. Could anyone drive there? Grant admitted that they could.

Other family members appeared on the stand, each affirming the brothers' whereabouts and that none of the cars worked very well. All these witnesses, however, were like rifle fire compared to the big guns the defense was ready to roll out.

The alibi witness was a pretty Portland girl named Cleo Wilson (no relation to the brothers), who had been the head usherette at the Playhouse Theater. An usherette was a woman, usually dressed in a fetching uniform and armed with a shaded flashlight, who guided theatergoers to their seats. The theater had been closed for two weeks. She quickly identified Utah and Turman as the pair she chatted with in the lobby of the theater on an evening in March. She couldn't, however, name the night.

They had come into the theater around 8:30 p.m. or 9:00 p.m. She was behind the refreshment station. They bought candy and then talked with another usherette nearby, short and blonde, before returning to Ms. Wilson. They asked for the head usherette, and she told him that she was now the head. The usherette whom they knew was no longer employed, she told the court, and she had taken her place.

She next produced the work schedule, of which she was in charge, and the theaters' "running time." The records, covering the three-day period from March 18 to March 20, were admitted as evidence for the defense. Goodman called her attention to the name "Lyon" on the schedule and asked if this girl worked as an usherette. She had, and for only one night, March 19. Cleo said that she had done her best to track her down but had so far had been unsuccessful. She said that she'd neither seen nor heard from

the woman since that night and had no knowledge of where she might be. She didn't know if she was married or not.

Goodman asked at what time the theater closed. She responded that it closed at midnight, but it varied by the length of the film. Jones interjected at this point, reminding her that she had left that evening at 9:00 p.m. She replied that there was a double feature that night: *Captain Fury* and *Captain Caution*.

Jones asked when she had been contacted by Goodman. She replied that it had been about three weeks after the crime. She said she'd talked the matter over with her managers. The prosecutor said that Sheriff Anderson had told him that she had said that Goodman "had frightened her and she didn't want to be involved." She denied that she'd said this. She said that the defense attorneys, Goodman and Clement, had taken her to the county jail to look at the Wilsons to see if she could identify them. The three had at first been refused admittance but returned later. She said that she looked at the pair for a very long time.

Jones asked how she happened to remember these two particular customers out of all of the others. She replied that it had been Turman's baldness. It was unusual to see a man so young be so bald. She told Jones that she had a remarkable memory. Asked to describe the clothing the men had been wearing, she said one had a jacket, but she couldn't recall which one. When asked about other films playing during the days before and after March 19, she could not recall.

Goodman asked if he had not told her to tell the truth to the best of her ability. Yes, he had done so, she said. Jones asked her if it were not true that she had told the assistant manager of the playhouse that she had tried to find the timecard but that it had been destroyed. Were the time sheets destroyed? If so, where did this time sheet come from? She denied the conversation with the manager, but after more questioning, she said, "I don't believe I said that. I cannot be sure."

Goodman called the theater's assistant manager, Ted Osborne, who identified the time sheets as the type they used. He told the court that the timesheets were kept by the head usherette.

Testimony was given by four usherettes at the Playhouse Theater on Morrison Street in Portland that the defendants were watching a movie at the Playhouse Theater. Most said it was sometime in March. None could say when the brothers left.

There was a stir when Betty Mae Lyon, the so-called missing witness, was called to the stand. She denied that she had given a statement to Portland

detective Mike O'Leary and a state policeman. She denied that she had worked on the nineteenth. She said that she had not been sure. She was certain that Utah and Turman were the men she'd talked to on that night. She looked at Utah two or three times, she said, because she thought he resembled someone that she knew. She could not produce her check stub, she said; it had been in her purse but she could not find it.

Stacie Goodman, the flamboyant witness for the prosecution, was called by the defense. The brothers had said that they had made a trip to Silverton to visit their father, Mose Wilson, staying until after dinner. Stacie told how she and her two daughters had seen the boys arrive after 2:00 p.m. She had previously testified that she knew them as Ted Davis and Bob Olson. She had seen them again, she said, on the nineteenth just as she finished dinner. And it was 7:45 p.m. or so when they left. Her two daughters, she said, were playing ball in the road in front of the house.

Naoma, the ten-year-old, followed after her mother to the stand. Judge Cushing asked if she knew what it means to tell the truth. She assured him that she did. She knew the two men as Teddy Davis and Bob Olson. She knew their father, Mose, as Bill Wilson. She had seen all three men on Sunday afternoon. Had she seen them in the evening, when she was playing ball? No, she said, she hadn't seen them. Irwin Goodman was stunned by that answer. He dropped the line of questioning.

Jones took over. "Did anyone ever talk to you about the case, Naoma, and tell you not to testify that you had seen the boys?" She answered, "No." Did Bill Wilson "ask you to say the boys were back later that night," Jones asked. "Yes," Naoma answered. "That's all," said the prosecuting attorney with a smile.

Irwin Goodman had to repair the testimony. He rephrased the question. Had she seen the boys come to her home on that day? She answered, "They rode." Did that mean that they came in a car? Yes. Had she seen it in the day and later that evening? Yes, it was a black sedan. That answer really didn't help the defense either.

Carl Whitney, a friend of Turman and Utah's, was a power saw operator from Kalama. It was he who had brought the issue of the power saw into the lives of the Wilson family. Whitney had been convicted of burglary with Utah and was also on parole. He had heard the rumor of a stolen power saw and feared that either he or Utah would be suspect. He went to Utah's house and told Gladys Cline, Utah's mother-in-law, of the problem. He had returned on March 21 but saw police cars nearby. He did not stop, he said.

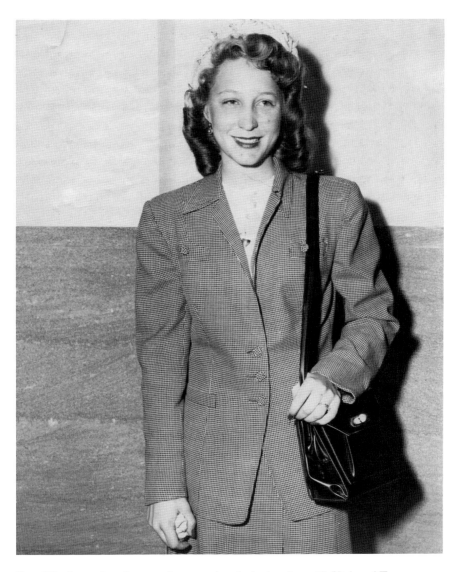

Betty Mae Lyon, the usherette who swore that she had spoken with Utah and Turman on the one night that she worked. She claimed it was the night of the murder. That was not true. *From the* Vancouver Columbian.

On Saturday, June 24, Turman took the stand again. He was there for eight hours. He was a calm and collected witness. He sidestepped all the traps laid out by the prosecution, handily parrying any incriminating questions. The only outward sign of nervousness was the constant rapid blinking of his eyes. He never deviated from the story that he had told the

detectives and the press. He had visited his father. He and Utah had gone to a movie. They had car trouble. They saw police at their mother's house and spent the night in the woods.

The defense had not called the sheriff to testify. That would have been the most dramatic testimony yet. However, bombshells were to be released by the prosecutor.

THE REBUTTAL

June 26 was one of the most intense days of the long, arduous trial. A Portland detective, Mike O'Leary, testified that he'd been asked by the prosecuting attorney to contact Betty Mae Lyon, the missing witness. He checked her husband's name and found her father-in-law. He agreed to accompany O'Leary to speak to her. He said that they had discussed her work at the Playhouse Theater. She had told him that although she couldn't remember what date she worked one shift, she was positive that it wasn't Sunday, March 19.

Goodman said, "Lyon wasn't very anxious to talk to police officers, was she?" "She was very much so, sir," O'Leary answered, although it was true that she didn't know he was coming to talk to her.

Oregon State Patrol officer Robert Wampler said that he was also asked to interview Betty Mae Lyon, and he did so on Saturday evening, June 24, preparatory to bringing her to Vancouver. He spoke with her sitting next to her husband.

She had said that she couldn't remember which date she had worked. Asked if it was on March 19, the patrolman said, the answer was no. She had produced a check stub from the theater dated March 27, 1950. She agreed to go to Vancouver with Officer Wampler on Monday morning and said that her mother-in-law would go with her. She and her husband walked Wampler to the patrol car, arriving just as a dry cleaning truck pulled up. She exclaimed that they were delivering her suit, and she'd be well dressed for her appearance in court. When Wampler arrived Monday

morning, there was no one at home. This was why she was not in court that morning.

Goodman approached the officer. "Mrs. Lyon wasn't under oath when she talked to you, was she?" he asked. Wampler agreed that she was not. Both officers also testified that she told them that she had been approached by Cleo Wilson, the head usherette at the theater, who had asked if she remembered a conversation with two people at the theater on the night she worked there. Cleo had testified that she had been unable to find Betty Mae.

Prosecution then brought on Robert Butts Jr., who was the manager of the Playhouse Theater. The official record, he said, showed that Betty Mae had indeed worked only one night, and that was March 22, not March 19. The audience gave a communal gasp. This was directly at odds with Cleo Wilson's testimony. Butts had brought with him to court the official payroll sheets of the theater, which had been certified by him as being correct at the time they were turned in. That record, covering March 14 to March 20, did not include Lyon's name.

Goodman brought out that Ted Osborne had made up the sheets and Butts had signed them. Goodman asked how many people ushered the night of March 19; Butts said that he did not know. Goodman showed Butts the defense's exhibit, the time schedule submitted by Cleo Wilson with the name of Betty Lyon and another woman, a Miss Stevens. The defense attorney pointed out that neither of these names appeared on the theater manager's payroll sheet.

"This is not the record that Mrs. Wilson handed to us to make up the payroll," Butts said. "This is not the one from which we made up the payroll." Once again a gasp and a murmur arose from the audience. Goodman objected to the introduction of the payroll sheets on the grounds that Mr. Butts did not know how many people worked on the evening of the nineteenth. His objection was overruled.

R. DeWitt Jones zeroed in now. He offered a second piece of evidence that blasted the defense's claim: the time sheet covering the period from Tuesday, March 21, through March 27. The paper included the name of Betty Mae Lyon and showed that she worked a single four-hour shift on March 22. It was admitted to evidence.

Jones asked when the payroll was made up. Butts replied that if an employee received a check dated March 27, it would mean that she had worked after March 21. Jones turned to the defense table and demanded the check stub that had been promised be produced. Sanford Clement

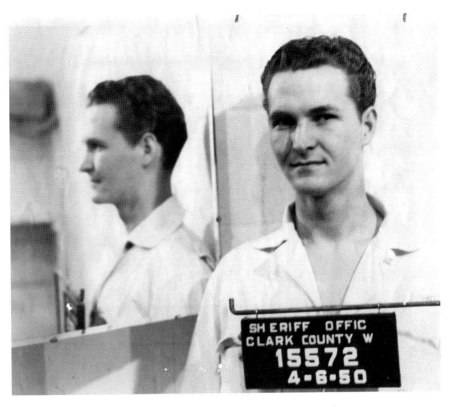

Utah Wilson's mug shot is of a man still in his twenties but who has no future left to him. His schoolboy demeanor has slipped a bit. *From the* Vancouver Columbian.

answered that it would be in court in the morning. Mrs. Lyon had said that she couldn't find the check stub, although it was in her purse the day before. Judge Cushing had ordered her to bring the stub "this day," but she had not.

Robert Butts went on. New employees were being tried out, he said, because the theater was planning to switch to an all-day operation. Those new employees worked the week of March 21. At the defense table, a long discussion with covered mouths erupted. Afterward, Mr. Goodman asked if Cleo Wilson could testify the next day, even though she was in the courtroom. Jones and Judge Cushing agreed.

DeWitt Jones questioned Utah Wilson in the afternoon. This time, Utah hesitated and became confused. He could not remember where he had been on certain dates. "There are so many things that we did," he stammered. "So many dates to remember. It's hard to keep them all straight." Asked why

he could not remember those dates but could remember clearly what he did on March 19, Utah answered, "Because I had to remember what I did on March 19th."

"Why is that Utah?" Jones shot back.

"Because I'm charged with murder!" Utah fired back. It was hard to remember, he said, because "we'd gone to Camas so doggone many times that week I can't remember." He testified that they'd left the Camas area after 11:00 p.m. on March 26 and slept in the car that night. The next night, they stayed in a motel in Woodland, California, and arrived in Sacramento the next day. Had he not told the officers in Sacramento that he and his brother had been fishing all day on the day of the murder? No, he'd been "a little bit misquoted" on that answer, he said.

Going back to Utah's probation, he was asked if he realized that Judge Cushing, before whom he now sat, was the judge who had deferred his case and was the only one who could revoke it. He did not. He agreed that his probation officer, Frank O'Brian, had always been fair with him. Hadn't he been told not to associate with Turman? No, he'd never been told that, although Turman's name had come up in conversations.

Jones's rebuttal questions focused on the contradictions in Utah's testimony. Had he not told Deputy Paul Markley that he'd been fishing on the Wind River? Yes, but it was years ago. Hadn't he sought friendships with law enforcement? No, never. Didn't former deputy Thomas McKeag intercede for him with Judge Cushing to put him on probation rather that prison? Yes, he had. Hadn't he brought fish to deputy sheriffs? Yes, he had. Hadn't he told his parole officer that he had not left Washington for fear of violating his parole? No, he had been misunderstood. Jones ended his quizzing of Wilson with questions about a pause at Tony's Market, asking what time the brothers reached this place. Utah said he wasn't sure, but it would take about a half hour from the theater. Waddles, a restaurant next door to the market, was dark when they drove up. What time does Waddles close on a Sunday night? Utah didn't know.

Goodman's only question was about his treatment by deputies and his probation officer, Frank O'Brian. They'd always been good to him, Utah said.

Next up were three officers who testified that no cars had been dispatched to the area of Eunice Wilson's house in the early hours of March 20. Cletis Luse, who'd operated the Sheriff's Department radio that night, produced the log of the radio. There were three Clark County sheriffs' cars on duty that night—on the Pacific Highway, at Orchards and Battle Ground; on the Manor Highway; and on Minnehaha. None was in the Fern Prairie area.

Sergeant Coshow of the state patrol produced his records. Dick Reacksecker, the patrolman assigned to that area, went off duty shortly after midnight. Reacksecker was asked by Goodman if he knew where the Wilsons lived. He knew the residences of both Eunice and Grant. At that night at that time, there were no cars in either district.

Officer Jerry Stroman of the Vancouver Police Department also said that no cars had been dispatched to that area, adding that the police only operated within the city limits of Vancouver.

Utah's probation officer, Frank O'Brian, told of speaking with Utah in the county jail after the arrest. He said that he'd asked Utah if he had really run away for fear of his probation being revoked. He asked if Utah didn't think that he, as his probation officer, would not have helped him as best he could. Utah had said that the parole revocation was just something that Turman told the officers in Sacramento. O'Brian went on to say that he had told the younger brother to stay away from Turman. That did not mean that he could not see Turman at his mother's house, but he should not be out in a car with Turman. O'Brian was adamant about that, he said. He had been sure that Utah understood that. He told the court that Utah had been given a list of the rules and regulations at the time of his probation. Utah had said that he understood them.

When O'Brian left the stand, Jones told the judge that he was finished with his rebuttal, but the state would not rest until the defense submitted Betty Mae Lyon's check stub.

Utah was the final witness called in what had become the longest trial in Clark County's history. Defense attorney Irwin Goodman asked him again about threats made in the Sacramento jail by Vancouver detective Julian Ulmer. Utah responded by saying that Ulmer had told him that if he would confess, he would only get seven years; if he did not, he'd get thirty years for violation of parole. "Were there threats against other members of the family?" Utah said yes. He launched into the story of the power saw, without naming the object. He said that they intended to avoid arrest from March 18, the time of the theft, until April 10, when he had an appointment with his probation officer, O'Brien. He was sure that he could convince O'Brien that he had nothing to do with the theft of the power saw. He hoped that O'Brien would understand why he had left the county without permission and therefore not revoke his parole. He knew he'd be scolded for fleeing to California with a convicted felon, Turman, and O'Brien would surely understand having the Llama automatic pistol. As far as the fingerprints on the beer bottle, well, it was

obvious to him that the police had set him up with a bottle taken from his trash bin a few blocks away.

Goodman immediately filed a motion for dismissal of first-degree murder and kidnapping charges and for a directed verdict of acquittal. That motion was denied. He said that the state's case was circumstantial, that no one could positively place the Wilsons at the scene of the crime. The paycheck stub was never produced; Betty Mae Lyon swore that it was irrevocably lost.

Final arguments began on Wednesday morning, June 28, 1950. The prosecution led off with R. DeWitt Jones's summation, which lasted an hour: Utah's fingerprints found on the beer bottle at the scene, the brothers' actions after the abduction, the switching of cars a minimum of three times, fleeing to California—all were indicative of guilt. They also used false names. Even if the brothers had been at the Playhouse Theater that night, there was not one witness who could prove that the brothers were at the Playhouse Theater during the hours that the kidnapping had occurred.

For the defense, Irvin Goodman concentrated on the ineptitude of the investigation. He argued that the state's case had not contributed any testimony or hard evidence linking Utah and Turman to the crime. None of the witnesses could positively identify the defendants as the men who had forced JoAnn into the car that dark night. He told the jury that Clark County authorities failed to make every effort in the investigation and that the Wilson brothers were merely scapegoats to cover up their incompetence. He asked for a verdict of not guilty.

The jury was escorted out of the courtroom. The audience left and wandered about in the hallways, waiting for one of the elevators to carry them to the ground level. The attorneys sought dinner. The families of the victim and the accused simply waited.

THE VERDICT

At 3:45 p.m. on June 28, the case was given to the jury. The brothers' fate now rested with the four women and eight men who had listened to the evidence and heard the arguments since June 12—sixteen long and wearying days.

Judge Cushing, in his twenty-eight-page set of instructions to the jury, stressed the importance of the "critical hour"—that is, the time of the crime that was between 11:00 p.m. and midnight, when the events leading up to the death of JoAnn Dewey began. He explained that a first-degree murder charge need not require premeditation if it involves a death occurring during a rape or a robbery—in those cases, all involved are equally guilty. He explained flight and how it might affect the outcome. If the jury found that the act actually did happen and that immediately thereafter they had fled from the scene, then the flight is a circumstance to be considered by the jury along with other evidence.

In a full page, he explained circumstantial evidence and direct evidence. The testimony of a witness is direct evidence; circumstantial evidence is proof of certain facts and circumstances from which they may infer connected facts. He went on to say that conclusion based on direct evidence is made based on belief in the truthfulness of the witness. A conclusion based on circumstantial evidence depends on whether such conclusions reasonably result or are naturally inferable from the facts and circumstances proved. He explained that an alibi must show that the defendants were so far away that there was no possibility that they could not, with ordinary exertion, be at the place where the crime occurred.

Further, each charge must be considered as if it were the only crime charged. If the jury accepted that the defendants were too far away to commit the crime, then they must acquit. If they believed otherwise, then they must consider that fact. The jury listened intently.

At 10:45 p.m., after deliberating just five hours, the jury foreman rapped on the door to inform the bailiffs, Al Cox and Irene Back, that they had reached a verdict. The judge was summoned. Seemingly from nowhere, a small crowd of perhaps two dozen people appeared in the hallway of the fourth-floor courtroom.

Prosecutor R. DeWitt Jones, after his summation, had turned the case over to his assistant, Don Blair, and left with his family for a long-delayed vacation in British Columbia. He would not be in at the finish.

Smiling and confident, the Wilsons reentered the courtroom with their attorneys. They appeared stunned when the jury foreman, Robert E.

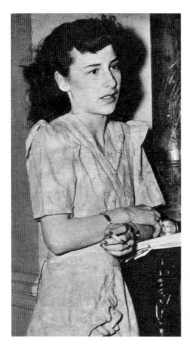

Lucille Cline Wilson, a petite, chain-smoking teenager, had no idea how her life would change when she married Utah Wilson. In this image, she waits in the hallway of the courthouse. *From the* Vancouver Columbian.

Davies, announced that Utah Galilee Wilson and Turman Eugene Wilson had been found guilty of first-degree murder and kidnapping; the jury decreed the death penalty should be inflicted on each defendant for each offense. He added that the jury's verdict had been unanimous, as is required under Washington law for a death verdict.

Court Clerk Wilma Schmidt polled the jurors one by one on their verdicts on each count and on the death penalty. Her voice seemed to nearly break at times. This was a solemn moment. Each juror had taken on his or her duty seriously. On each count of guilt, and on the recommendation of death, each juror affirmed that this was his or her individual opinion.

Lucille gasped and then broke from the courtroom sobbing. Eunice sat dead still and composed. This would leave her just one son who was not in prison. Assisted by her daughter, Patricia, and her son-in-law, Clarence Ostenson, Eunice soon left the courtroom. Waiting in the hallway were

Lucille's mother, Gladys Cline, and Lucille's brother, a husky Lloyd Cline. Lloyd used his bulk to shield Eunice from the cameras as they left the fourth floor.

On Friday, June 30, Judge Eugene Cushing sentenced both "to be hanged by the neck until dead" at the state penitentiary at Walla Walla.

Irvin Goodman immediately moved for a new trial and, as well, an arrested judgment based on judicial error. The judge denied that motion. Goodman then announced that he intended to appeal the verdict to the Washington State Supreme Court. Judge Cushing stayed the execution until the appeals process had run its course.

That course would be a long and tedious one. The next phase of the legal chess game had begun.

LEGAL MANEUVERING BEGINS

On June 26, the last night before the trial ended, Lucille Wilson came to the sheriff's office late in the evening to talk with Deputy Luse. She told Cletis and the sheriff that she knew very little about her husband's brother, Turman. She had met him the day after Utah's release from the county jail. She and Utah had dinner at the Wilson home at Green Mountain. Turman was there, as well as one of Turman's friends. She couldn't remember his name, but he said he was from California. The sheriff brought up several names, including Marvin Colby. None of those names registered. He continued reading off names. Lucille thought she recognized James Cox's name. He was one that had been mentioned as a friend of Marvin Colby's. Sheriff Anderson assured Lucille that he would be sure that James Cox would be investigated. He was, and that man was cleared as well.

On July 1, R. DeWitt Jones announced that he was considering filing perjury charges against some of the Playhouse Theater usherettes who testified for the defense. To an *Oregonian* reporter, he said, "Their evidence, to state it as mildly as possible, was conflicting. The question of taking final action will await a study of the trial record....In my own mind, there is no question that false testimony was given," Jones continued. "People who take the witness stand and lightly hold up their hands to swear in truth and then tell stories that are not true."

Cleo Wilson's testimony had been that she had searched for and had been unable to locate usherette Betty Lyon, who had worked just one night. But when Lyon had testified just a few days later, she said that she had received phone calls from Cleo asking her what days she had worked and whether

she had talked to the Wilsons. When Jones had the record read, she tried to explain the discrepancy but was stopped. Jones pointed out that the timecard had been suddenly found, with Mrs. Lyon working on the nineteenth, but the manager of the theater stated that the timecard admitted to evidence was not the one that was turned in to him to make payroll.

Police officers and the prosecutor had talked to Mrs. Lyon and had her scheduled as a state's witness. At that time, she had told both the detectives and Jones that she had not worked on the nineteenth, but two or three days later. The theater manager's payroll showed that she worked on the twenty-second.

Later in the *Oregonian* interview, Jones said, "This variation in testimony and in stories told investigating officers is a serious matter and hampers the true course of justice. In fairness to the people I was elected to represent and to the oath of office I took, I must take whatever legal steps seem to be required of me." In the end, no charges were filed. The course of the trial was not altered by their testimony, and it would appear to be merely vengeance.

Irvin Goodman issued a statement in September 1950 decrying the prosecution's failure to call Sheriff Anderson to the stand. He said, "In our view, it was his duty to take the witness stand so that the jury could have the benefit of our cross-examination of him under oath. Instead he now releases unsworn statements to the public. It is regrettable that the sheriff and certain other officials have persistently tried those boys at the bar of public opinion long before their trial began." He had not subpoenaed the sheriff either.

The sheriff responded that "anything I had to say would be hearsay evidence and would not have been admitted. I could not testify about conversations overheard between two other parties."

On June 30, 1951, Irwin Goodman turned over a letter to Chief Harry Diamond. He advised the press that he was "withholding judgment" on the letter. Scrawled and misspelled, it read:

> *Mr. Goodman—This is to tell you that I killed that gurll by a bad mistake. I feele bad aboute it and hate to them two boys get killed over it too. I got her ring and her other things is up there by some big rocks about a mile up the road from me. The Bridge. You will see that this is the truth aboutt it.*
>
> *It was a bad mistake and I'm sorrey. If they get me I will tell all. I have wrote another letter to the Vancouver Police day before yesterday. The 26ᵗʰ.*

[signed]

Ime sorry

Diamond had his detectives investigate the letter. There were no discernible fingerprints on the letter. The detectives tried to pinpoint an area with big rocks near any bridges near the crime scene. Nothing was found. The letter writer never appeared again—another stalemate. Goodman said that he'd received many letters from many places expressing the belief that the Wilsons were innocent.

More strange testimonies would appear in weeks after the trial. On July 12, an odd call came into the jail. The caller, a Mr. Green, said that he wanted to come to Vancouver to clear the Wilson brothers. He said that they had been protecting him, and he wanted to clear it up. He'd call a Broadway cab and be right over. Deputy Luse asked for his address, which he promptly gave and then screamed when he realized what he'd done. The deputy said that he'd send two plainclothesmen to pick him up and bring him to the sheriff's office. He agreed. Luse and another deputy drove to Portland to pick up the man.

Once at the sheriff's office, he said that the brothers had to be innocent because they'd spent the entire week staying at his house as guests of his butler. Unfortunately, the butler had been fired and was now living in California somewhere. He said that the brothers had picked up JoAnn as a "chippie" ('50s slang for a prostitute), and when they were done, they dropped her off somewhere. He asked to speak to the Wilsons. They were brought out, but neither knew him. He told them that they didn't have to protect him anymore. They asked to go back to their beds.

The deputies drove Mr. Green back home. As they found out, he had had a butler, whom he described as a Filipino, who had been booked into the Clark County Jail the year before. They checked that, and it was true. The sheriff decided that this was an angle to investigate. He would continue to interview Green until it became obvious that his physical and mental health were failing rapidly. He died soon after of a "Central Nervous System disorder of long standing."

During that time, on July 17, Lucille again met with Cletis Luse. She told him that she had gone along with the boys' story because she thought it was a frameup. Then she saw the evidence that the state presented at the trial. She had suddenly realized that they had used her for an alibi. She had said some things on the witness stand that weren't true; she said that's how she'd been instructed, so she'd just followed along until she realized that they were indeed guilty. She told Luse that she wanted to get a divorce. In fact, she had filed the action for divorce on July 15. She intended to start a new life elsewhere. She and her mother had moved to the Liberty Court Apartments in the Fruit Valley neighborhood of Vancouver.

On August 2, 1950, Goodman filed a supplemental motion for a new trial, which was denied because it had not been filed in time. However, the Washington Supreme Court heard the appeal on May 10, 1950, according to the *Columbian*. Its decision was unanimous and clear: "The appellants had a fair trial and we cannot see how the jury could have arrived at any other verdict than it did, even had all the excluded and so-called newly discovered evidence been presented to it."

Goodman stated that he was shocked at the court's verdict, and he immediately filed a petition for a retrial. That, too, was denied. On August 10, Goodman again told the court that he would file another appeal. This would be based on new evidence uncovered since the trial. He and Sanford Clement conferred with Judge Cushing. The Wilsons had just $700 left; the cost of the appeal was $2,500. Would the court cover part of the cost? Cushing approved the expenditure. The county would pay the balance, according to the *Bend Bulletin*.

At the September primary election, Sheriff Earl Anderson came in fifth in a field of six Democratic candidates for sheriff. He was now a lame duck.

On October 8, 1950, Turman was restless. He began a conversation with the jailer, H.G. Hanson. He began to go over the trial and the evidence as it was presented. He said that he did not see how he'd been convicted.

Hanson quoted him in his report that day: "They found some hair in the Pontiac, but the doctor said it could or couldn't be JoAnn Dewey's....I know it couldn't be the girl's hair because we never had her in the Pontiac." Hanson then wrote, "Turman talked rather freely to me as I, in his mind had no information on the case. The way Turman make the remark about the hair led me to believe that he had let something slip as he did a little more thinking after this. I did not question this statement because I did not want him to think I would be listening for any slips in the conversation. Turman seems to like to talk a great deal and usually keeps up better than his half of any conversation."

A bizarre investigation began on October 17, 1950, with a phone call from a Hildur Kane, who identified herself as a public relations woman. She had quite a story to tell. Kane told them that in her work in public relations, she'd met another PR person named Russell Duke. She told him that she was working on a magazine story for a New York publication. He told her he had inside information on that case. Sheriff Anderson told Detective Neal Jones to stop whatever he was doing and accompany him to Portland to interview Mrs. Kane.

She had learned, she told them, that Reverend Ralph Cranston, Grant Wilson's Assembly of God minister, was not Ralph Cranston at all but

rather a Canadian named Charles Walker. She went on to say that this Cranston was a convicted felon several times over in Iowa or Illinois. She said that she had found out that Cranston had fled Canada to avoid prosecution on another felony charge. She had been told that he owned an apartment building that was actually a brothel and that he had often brought JoAnn Dewey to that apartment building. Not once, she added, but several times.

She had gone on her own to Camas to meet Cranston, she said, and he admitted that he did indeed own the property along with an Emma Kauffman. She felt he had been evasive in his answers to her. He represented to her that it was solely used by students at Reed College. She spoke with Muriel Cranston, the man's wife, who appeared irritated by the questions. That raised her suspicions even more. That, she said, was when she determined to call the sheriff.

She then handed a list of the tenants to the deputy, saying that she didn't talk to anyone at the building, but the place received ice from Montville Ice and Coal Company. She didn't know what college students would want with ice. Kane didn't want them to tell Duke that she had betrayed his confidences, that he had trusted her with the information. The sheriff assured her that she had done the right thing but that they would tell Duke from where the information had come. They would have to interrogate him for corroboration. After thinking it over, she agreed.

Deputy Jones, along with Sheriff Anderson, then headed to Camas and picked up Reverend Cranston. At the sheriff's office, he was practically mute with rage. He was questioned about JoAnn and the house. He denied knowing JoAnn. He denied ever having been in Illinois or Iowa or anywhere in the Midwest. He denied that he was wanted in Canada. Yes, he was part owner of an apartment house that rented to college students. He was fingerprinted, and his prints were sent to the FBI as well as the Royal Canadian Mounted Police.

Neal Jones spoke with several Portland officers and businesspeople of that city. He was told that Duke was given to tall tales and that any statements he made should be thoroughly examined.

The fingerprints from both the FBI and the Mounties were clear. Reverend Cranston had never been arrested in either country. He was not wanted anywhere in either country. His name was, indeed, Ralph Cranston, a British-born immigrant via British Columbia. The apartment house was indeed a domicile for Reed College students. The sheriff apologized to Cranston, profusely.

A phone call from Marvin Colby on November 20, 1950, to the sheriff's office brought up the name of Carl Johnston. He was an able-bodied seaman, who, Colby had remembered, had a car similar to one used in the crime. There were to be no uninvestigated leads.

Deputy Howard Hanson followed up on this one. Carl Johnston was on the *Oregon Trader*, sailing from Portland to Idaho Falls. Deputy Hanson went to the Shipping Commission in the Failing Building in Portland. The Sailors Union of the Pacific was the next stop, and he learned that Johnston was now on the SS *Montana*. The secretary for the commission remembered that someone had called a week or two earlier asking for Johnston's next of kin and who was his death beneficiary. Hanson surmised that Johnston must have floated a loan somewhere, perhaps to help finance an attorney should he be involved.

The next stop was the Coast Guard, asking for a photograph of Johnston as well as about any relatives or other information. Of course, the FBI was also contacted for the same information. The bureau replied on December 1 that Mr. Johnston had no record with that body other than his licensing as an electrician's helper with the merchant marine.

The Puget Sound Pilots Association in Seattle supplied the ship movements for the *Montana*, owned by the States Steamship Company, headquartered in Vancouver at 1004 Washington Street. The *Montana* arrived at the pilot station at Port Angeles on March 16 and immediately was taken to Anacortes, arriving at 9:00 p.m., March 17. It was at Seattle, Pier 28, on the twentieth and moved to Todd Dry Dock; on the twenty-fourth, it sailed for Vancouver, British Columbia. Johnson signed off the ship on March 21. He would have been able to be in Vancouver over the weekend around March 17–20.

Hanson took Johnston's photograph around to several witnesses who had seen a man with the Wilson brothers at a theater in Portland. All the witnesses said that Johnston bore no resemblance to the man they had seen. After all that footwork, it was another blind alley.

Another twist in the convoluted case occurred the night of November 28, 1950. Three juveniles, in custody for theft at a service station, became enthralled with Turman's tales. They were in the presence of a real gangster. He taught them how to stage a jailbreak. They were to start a fight or flood the cell with water. Then, he went on, when the jailer came into the cell, overpower him. Get his keys. From the fifth-floor jail, there is a trapdoor into the judges' chambers below. The jailer would have the key to the trapdoor. They would go through that, drop into the judge's chamber, go out through the courtroom and get away.

That's exactly what the boys did. They plugged the toilet and called sixty-six-year-old jailer Russell B. Johns. They beat him into unconsciousness. When they got the keys, they immediately freed the Wilsons. Utah and Turman examined the keys and found that none would unlock the trapdoor. The Wilsons went into the commissary and armed themselves with knives and a cleaver. They forced the trio back into their cells and locked the door.

Deputy John Keenan, on duty downstairs, picked up the inter-office telephone. On the other end was Turman Wilson. He said, "This is Wilson. There's been a break. They have Johns locked up."

A stunned Keenan called city police and sheriff's officers on patrol. Deputies rushed to the fifth floor. They found the escapees locked up and Utah and Turman roaming free through the halls. Turman reportedly said that he had no intention of trying to escape: "They'd have put a bullet in my head." He was undoubtedly right. In an interview, Bill Farrell, a former deputy and retired Vancouver police lieutenant, said, "I sat in a chair in the hallway with a shotgun for several nights after that just waiting for them to make a move. Poor old Johns never recovered from that beating." Johns died just over two months later. No one was ever charged in his death. The cause of death given was pneumonia.

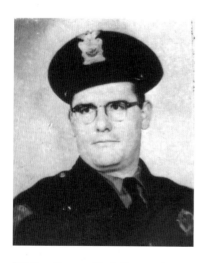

Bill Farrell was a Clark County deputy sheriff. He joined the Vancouver Police Department after the exit of Sheriff Anderson and retired as a lieutenant. *Vancouver Police Department.*

On January 8, 1951, Clarence McKay, a retired deputy sheriff, was sworn in as sheriff of Clark County. The next day, Monday, Earl Anderson left the office along with fifteen of his deputies, their appointments terminated. Among them were Bill Scott and Arthur Swick, who had been convicted with Anderson in the event in Meadow Glade. Chief Deputy Neal Jones was succeeded by Ben P. Pearson, who had been in the Sheriff's Department for eleven years until World War II, when he had become a lieutenant in the Coast Guard. Since the war, he had been an officer of the guard at the J.D. Ross Substation in Vancouver and a student at Clark College.

The Wilson family's saga would add another chapter during this post-trial

time. Mose Wilson was arrested on an assault charge on February 26, 1951. He'd threatened a neighbor with a knife, according to Silverton constable Emery Jackson. The complicated story began with a chicken dinner and thirteen bottles of beer. Three men, a girl and Mrs. Stacie Goodman were involved. All were arrested. Another man declared that he grabbed a pair of scissors from a sewing basket, poked them in Wilson's back and marched him out of the house. Two other men were arrested as a result of the same fracas. Wilson's landlady, Stacie Goodman, who had testified for the prosecution and for the defense at the trial, paid his bail and, later, his fine. Stacie was a widow. Her husband had dropped dead during an argument with Mose a few months before.

On June 11, 1951, Glenn Wilson was released after serving the ninth of his ten-year sentence for rape. After resting at his mother's house for a day, he and Eunice visited the brothers at the Clark County Jail. Sheriff Clarence McKay knew the Wilson boys' expertise in escape, so he had several officers in plainclothes about, as well as his uniformed officers. Two were in the visitors' room as the four Wilsons chatted through a fine-mesh screen. The jailers said they made no effort to listen in on the conversations.

On July 18, 1951, the Wilsons were back in front of Judge Eugene Cushing. Their appearance was due to an 1854 statute that provides that if, for some reason, the original sentence is not carried out, the condemned shall be taken to the county seat in which they were tried. Jones added that, in his opinion, it was cruel for longtime cases such as the Wilsons' to be dragged on like this. Both were dressed in white coveralls that they'd worn on the trip from Walla Walla. In the courtroom were Mose and Eunice Wilson; two brothers, Glenn and Grant; and Charles Lester Wilson, the son of the brother, Lester, who'd been killed in the war.

Lucille, Utah's wife, was not present. She had divorced him immediately after the trial. They watched as Cushing signed the death warrants setting Saturday, August 30, as the new execution date. Immediately after the warrant was signed, Irvin Goodman asked to make a statement. Judge Cushing stood and said, "I'm not interested in any statement."

Turman had stood. He asked, "Can I say something, Your Honor?" There was no answer, as the judge had already left the courtroom. There was a moment of silence, and Turman gave a slight shrug. Again, Goodman notified the court that he was filing a petition with the United States Supreme Court.

Less than two hours later, two sheriff's cars appeared from the garage under the courthouse. In one was Sheriff Clarence McKay with the Wilsons,

chained to each other. There was a deputy in the back with the brothers and one in the front seat. By dinnertime, they were in Walla Walla.

On September 21, 1951, Vernice Booth of Portland called on Goodman's office. She told him that she was an acquaintance of the Wilson brothers. She signed an affidavit that she had seen the Wilsons at a Portland restaurant early in the evening of March 19. She went on to say that an unknown boy, about twelve years old, on a bicycle, had rung her doorbell and handed her a package. In the package was a Navy blue skirt, bobby socks, a ring and a charm bracelet. She believed that the items may have been clothing worn by JoAnn Dewey. The clothing was sent to the University of Oregon Medical School; the jewelry was shown to the Dewey family. There were no bloodstains on the clothing,

The Seventh-day Adventist Church, while it does not expressly forbid jewelry, does frown on it. The Adventist nursing home where JoAnn was employed would have noticed had the girl worn such items. The Dewey family had never seen the items.

Goodman and Clement took Vernice Booth's affidavit to Washington's Governor Arthur Langlie, along with an affidavit from Deputy Howard Hanson that stated that there were suspects still who had not been investigated and cleared.

Associate Supreme Court justice Hugo Black ordered a stay of execution so that the court could consider the Wilsons' petition for a writ of review. On October 15, 1951, the court denied that petition. In Vancouver, the execution was rescheduled for Friday, November 30, 1951.

Goodman had defended twenty-one defendants accused of capital crimes. He had not lost a case yet, and he did not intend to give up. He immediately filed a petition for a rehearing and a stay of execution again with the Washington State Supreme Court. He charged that evidence was suppressed in the trial. He claimed that new evidence had been uncovered and the Wilsons had been deprived of their right of due process. That court denied the petition on November 27.

On November 29, Goodman filed a petition for a writ of habeas corpus and a stay of execution in United States District Court in Spokane. Judge Sam Driver rejected the petition, saying that he had no jurisdiction in the case. He was right, and Goodman knew it. He next turned to the Ninth Circuit Court. There was a last-minute reprieve from Judge William Healy of the Ninth Circuit Court of Appeals in San Francisco. He directed that "they shall live to such time that the Supreme Court of the United States or justices thereof, shall direct."

On Sunday, December 9, 1951, they had a perhaps eerie foretaste of their fates. The execution of Grant Rio, who had been convicted of a double homicide, was scheduled to take place on Monday morning. The night before, after his last meal of steak, he was allowed to remain in his cell long enough to listen to his favorite radio program, the *Jack Benny Show*, and to play cards with Utah and Turman. At 11:15 p.m., the guards came for him. He said goodbye to the brothers and was taken to the death cell. He was hanged early Monday morning.

Now into 1952, Irvin Goodman sent another appeal for review of the brothers' case to the U.S. Supreme Court. For the second time, the court refused to hear the case and on May 9 ordered the prisoners returned to Clark County Superior Court to set a third execution date.

On Wednesday, May 21, they arrived back in front of Judge Eugene Cushing. He took less than a minute to set the date as June 23, 1952, and adjourned the court. The brothers were again on their way back to Walla Walla. The courtroom was practically empty of spectators this time; only a handful attended, including the Wilson family.

Once again, Goodman went to the Spokane court. Once again, the federal court rejected him. This time, however, Judge Sam Driver granted a certificate of probable cause. That let Goodman take the case back once again to the Ninth Circuit Court of Appeals. On June 22, 1952, a Sunday, appeals judge Albert Lee Stephens granted an indefinite stay of execution to give the court time to determine if, indeed, there was probable cause for appeal. An answer came quickly. On July 10, the court decided that there was no probable cause and vacated the stay.

The Wilsons made the trip to Vancouver again, and once again Judge Cushing set their fourth execution date as August 15, 1952. Now their fates rested in the hands of Governor Arthur B. Langlie. Their only hope was a commutation to life in prison.

Petitions asking for clemency had been circulated all over the state of Washington. Irvin Goodman carried the petitions and letters to Governor Langlie, who had granted him a meeting along with Eunice Wilson; Grant and his wife, Hazel; a sister, Connie Wilson; and brother Glenn.

Another macabre development in a case already so strange occurred when Multnomah County sheriff Terry Schrunk appeared at Walla Walla State Prison accompanied by two detectives. He wanted to meet with Utah. Later, Utah released a statement saying that Schrunk had offered him his life in exchange for a confession to two 1948 murders. Schrunk said that he believed Utah was implicated in the unsolved slayings of Pierre Alfred

Left: Turman Wilson, clad in white prison attire, waits in an office at the courthouse for yet another execution date; *Right*: Utah Wilson poses for the photographers as he waits with Turman for the court to be called to order. *From the* Vancouver Columbian.

Schultze on April 18, 1948, and Ramon Podlas on April 11, 1948. Both men had been found in ditches alongside roads. Both had been strangled. Utah had been in prison until November 1, 1948, so he might well have heard some discussion about the killings.

Schrunk immediately denied that he had offered Utah a deal and said there were three deputies in the cell with Utah during the conversation who would verify his denial. Irvin Goodman lashed out at Schrunk for "trying to get his name into a double hanging."

Former sheriff Earl Anderson sent a letter to Governor Langlie, with a copy to the press, that he now believed that thugs had hired Turman Wilson to kill JoAnn Dewey because she knew too much about the robberies that they had committed. He said that there were three men in the car and that Turman drove. Utah wasn't there, the fingerprints on the bottle notwithstanding. He also said that he knew the identity of one of the men and possibly the other. He added that portions of the recorded conversation that would prove that were withheld from the public. He withheld them, he said, in order to aid the investigation.

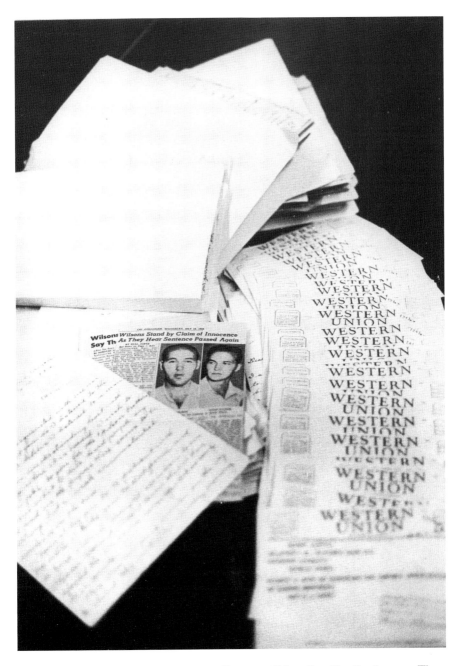

Stacks of letters and telegrams were sent to Governor Al Langlie asking for clemency. The governor chose not to grant it. *From the* Vancouver Columbian.

In response to Anderson's letter, that day Utah and Turman gave an exclusive and lengthy interview with the *Oregon Journal* in the warden's office. They said that Anderson's hypothesis that others were involved was simply not true. They stuck to their story of innocence. Both insisted that the "real killers" are still out there. Utah said, "Anderson, he might think he's right, he might be 100 percent sincere, but I know he's wrong. If they want to prove me innocent, let them go ahead, but that proves Turman innocent, too, because he was with me all the time....Anderson's sure that I'll break the case, but I don't know anything. If Turman's going to die, I'm going right with him."

THE COURT OF LAST RESORT

To add to the "stranger than fiction" events, Erle Stanley Gardner, famed author of crime fiction and the Perry Mason series, became involved in the case. He had helped found the Case Review Committee, an organization of attorneys and forensic experts whose aim was to reopen and investigate cases where it was believed a defendant might have been incorrectly convicted of crimes. The cases that they investigated were published in *Argosy* magazine and featured as the "Court of Last Resort."

Gardner—accompanied by Thomas Smith, a former warden at Walla Walla; Henry Franklin, formerly with the FBI; and Alex Gregory, former president of the American Academy of Scientific Investigators—arrived at Walla Walla. They were given permission by Governor Langlie to administer polygraph tests to the Wilsons and interview them. They also asked Langlie to allow questioning under sodium pentothal. The governor allowed this as well.

Gardner declared that the polygraph tests were positive, if not conclusive, and warranted a review of the case by a special committee of attorneys. Governor Langlie agreed. On August 14, 1952, the Wilsons were granted an executive stay for ninety days. The same day, Governor Langlie received the report of the so-called truth serum test that was administered to both men, with their permission.

Dr. LeMoyne Snyder, a medico-legal expert and longtime homicide investigator, along with Dr. Sol Levy, from the Hawthorne State Hospital, gave the test. The questions and answers filled twenty pages. The report, along

Erle Stanley Gardner, attorney and author of the Perry Mason books, investigated the arrest and trial of the Wilsons with a committee of the "Court of Last Resort." *Author's collection.*

with Dr. Levy's recommendations, was sent off to Governor Langlie. The package was marked confidential, and state officials refused to discuss it.

Turman had been the first subject. As soon as the drug was administered, he fell sound asleep. Utah then refused to take the drug until he was assured that Turman was all right. After a two-hour nap, the test was performed again. In the end, the results were inconclusive. Dr. Snyder said the conditions were not ideal and that they had no value in the investigation. When subjects are habitual liars, the results, they said, may differ.

The American Bar Association received a request by Gardner and Governor Langlie to study the case. It was troubled by this action. The body debated whether to participate; the argument continued all day. Eventually, it did agree and composed a list of prominent attorneys from which to form a committee. The list was forwarded to Governor Langlie. The governor chose three from that list: Erle Stanley Gardner, Harlan S. Don Carlos and Henry H. Franklin. They, along with Cody Fowler, a past president of the ABA, and James Bennett of the Federal Bureau of Prisons, began the investigation.

The ninety-day reprieve expired on November 15, and on Monday, November 24, 1952, the brothers once again were driven to Vancouver. Once again they faced Judge Cushing, who set a record-breaking fifth execution date. Never before had a condemned prisoner been granted so many reprieves from execution.

The governor's office in Olympia received the twenty-seven pages of the bar association committee's report on December 12, 1952. The governor reported, "I will take my time reviewing the report and any other information that may come up. I will keep my mind open until time to make the decision." He would not give a copy of the report to the press. That would happen after he himself had studied it.

Here is an abbreviated version of the report to the governor. The first paragraph summed up the findings: "Your committee has been unable to

find any evidence which detracts from the evidence in which the jury reached the determination of guilt. This is particularly true in regard to Turman Wilson." Further, it noted "that Utah Wilson did not physically participate in the actual abduction and murder. Utah however has identified himself with the crime by continually asserting both on oath in court and afterward to this committee that he was with his brother Turman every minute of the evening of March 19, 1950, and the early morning hours of March 20th, 1950." Under the felony murder law of Washington, participation in certain felony crimes that result in death, everyone involved is considered equally guilty, as Judge Cushing had pointed out to the jury.

The next section of the report recited Turman's record: "At the age of sixteen Turman Wilson, having already acquired a background of criminal activity, participated in the forcible rape of two girls. The police who investigated that case state that evidence showed Turman Wilson wanted to kill the girls so as to avoid the possibility of identification. The police also stated that Turman told them that if there was ever another instance of that sort there wouldn't be anyone available to identify him."

The committee had gone to the Oregon State Penitentiary to interview Rassie Wilson. He told them enough to show them that Turman had lied about his participation in that case. That visit also demonstrated that Turman had continually lied to the committee. Very shortly after Turman was released from prison for that kidnap and rape charge, he was arrested for an armed robbery in Portland. He was able to plea bargain that charge to result in just six months in the Portland jail instead of the ten years to life that was normal. Irvin Goodman was Turman's attorney on that case as well.

Turman also told the committee that he carried weapons and that he'd purchased guns knowing that it was a violation of the law. He did deny shooting at the officer in Kelso, for which he was never tried. The polygraph taken by the committee had showed that he lied about that.

The committee's report continued. Utah admitted to the committee during an interview that he'd committed so many burglaries he couldn't remember them. They learned that while Turman would work at various jobs, Utah did not. The two had money to buy expensive clothes and automobiles. They had $1,800 hidden away that they took with them to California. The committee decided that those reserves had come from criminal activity. Utah had told them that he had earned it by serving time for burglary.

The committee pointed out that the brothers had told conflicting and improbable stories of their whereabouts the day of and after the abduction. At seven o'clock in the morning, they showed up at Grant's house. They

told him that they'd been to Silverton to visit their father, Mose, and that they'd been to a movie in the town of Silverton. They said nothing about visiting a theater in Portland. They said that the night before, they'd gone to Eunice Wilson's home and had seen police cars there. They said that they were afraid that Utah's probation would be violated for associating with Turman, a known felon. They said nothing about a stolen power saw. Grant had heard nothing of it. The constant mention of that power saw played heavily during the trial. Yet according to the work done by the committee, no one had heard of it. The only basis for the story was that of Utah's fellow parolee, Carl Whitney. He was unable to supply a source for the story.

Lucille Cline Wilson testified that someone, she could not remember who, had told her about the saw. In her interview with Deputy Cletis Wilson after the trial, she confided that she said things that weren't true on the advice of the defense team.

The alibi witnesses and the usherettes' stories were probed in depth by the committee. Witnesses had testified that there were several sets of time sheets, some kept in the possession of the usherettes themselves and some with the manager, and some were dated at alternative times. The committee went to the head office of the theater and found that the time and payroll sheets had been preserved. Those payroll sheets showed the exact hours each employee had worked. That sheet showed that, indeed, Betty Mae Lyon had only worked one day, and that day was March 22, 1950.

The committee examined the sheet closely and reported that "the appearance of the sheet and the manner in which it was prepared, convinced them that it was a document of great importance." It also noted that the brothers' testimony that they had seen one movie and then again saw the usherette Cleo Wilson was a slip-up on Turman's part. Cleo did not work past nine o'clock on a Sunday, so his account would have to have been on a weeknight.

The committee did turn up additional witnesses, although it doubted their reliability. It was surprised that the defense did not call these witnesses. It was further surprised at the attorneys' explanation that they did not call them because they were sure that they would win. This was not acceptable to the committee of nationally recognized legal experts.

They pointed out that when the brothers met with Grant and discussed the case, which was emblazoned across the front pages all of the newspapers, they were, in the vernacular, con-wise. They knew that they would have to account for every minute of their time, yet they still left Grant with the

impression that they'd gone to a movie in Silverton. As late as March 31, Grant still believed that they'd gone to a movie in Silverton.

The committee went back to the beer bottle. That bottle was found within a half hour of the crime. The beer within it was still cold, poured out, and it left large bubbles. The bottle was picked up and taken to the evidence room at the police station. There it remained until March 21, when a fingerprint expert lifted the prints. The prints were at first rejected as not belonging to Turman, but they were later identified as Utah's. It was agreed that lifting the print was not a good investigative technique. Lifting the print literally means lifting it off the surface, leaving just a residue behind. The residue is what was later tested and was more difficult to identify. The original print was clear. The bottle was identified by three small dots on the label. That was the usual routine followed by Vancouver officer Forsbeck. Stanley McDonald, the Portland fingerprint expert, had the bottle but one day when he received word that identification had been made on the print and that it had been sent to the FBI for verification. He returned the bottle.

The Wilsons' defense offered the explanation that the bottle had been lifted from his trash and planted. As the committee pointed out, the bottle would then have had to be planted before the crime occurred. The committee went over several scenarios to find a way that the bottle could have been planted; all were discarded because at the time the bottle was found, the officers did not have Utah available. The fingerprint was the infallible proof that put Utah at the scene when the crime occurred.

The committee commented to the governor that even if "the officers were sufficiently venal to have framed evidence, to have committed perjury, to have substituted evidence, to have, in short, been completely corrupt, they simply didn't have the opportunity to have successfully framed the evidence in question on Utah Wilson."

The bottle was clean, save for Utah's prints, which told the investigators that it had been taken from the package by Utah and that it had not lain on the ground or in a trash receptacle. The committee looked long and hard at the recordings made by Sheriff Anderson. It found them all but unintelligible, but the sheriff had spent hundreds of hours listening to them, playing and replaying them, trying to decipher them. Each time a word or a name would be deciphered, it would be investigated. Hundreds of names were checked. The committee invested its own money to clarify the recordings. They were sent off to New York City, where several sound libraries examined them and more understanding was obtained. It was

still not enough to be introduced as evidence in a trial since the recordings should be understandable to an average man with average hearing.

Another aspect that throws doubt on the recordings is that the brothers were told a few days after they were put together that there was probably a microphone in the cell. Irvin Goodman told them that the walls have ears. In order to preserve privacy, he wrote questions to the brothers and had them write their answers. When Goodman was asked by the committee if any of the conversations could be considered self-serving, he agreed. He also agreed with the decision not to admit them in evidence.

On August 12, 1952, former sheriff Anderson had filed an affidavit that caused even more speculation. It was that he asked for a commutation of the sentence. He said that his interpretation of the recordings showed that Utah had not had any physical participation of the crime

Gardner pointed out the misconception that Anderson believed that the crime had not been solved. When the committee talked with the ex-sheriff, he said that he primarily wanted the commutation because he believed that there were other people involved in the crime and that, if the brothers were executed, that would end the investigation. He did believe that Utah had guilty knowledge of two other murders. Those were the cases that Sheriff Schrunk of Multnomah County had investigated. Anderson's views had changed after he sent the message to the governor. He told the committee that he could see no reason why Governor Langlie should be asked for a commutation of sentence for either defendant.

The committee strongly urged further investigation to determine if others were involved in the abduction. Did Utah actually participate in the abduction? As long as he insisted that he was with Turman every minute and Turman insisted that he was with Utah every minute, there is no way to prove otherwise. The prints on the bottle put him at that place at that moment, and they were definitive.

The committee admitted that it had started out sharing a common misconception, that Judge Cushing had permitted evidence of flight to be admitted but had not allowed the reason for that flight. The report went on to say that the court had ordered the defense to show that a power saw, any power saw, had been stolen before claiming that theft as a reason for flight. The defendants, of course, could not show that.

The story of the saw had already been placed before the jury in the testimony of FBI Agent Tull and by Officer Ulmer. Gladys Cline had said that she had been told that there was a power saw stolen on the twenty-first by a co-worker of Utah's and that Utah had already fled

when the knowledge of the power saw was introduced. The Washington Supreme Court decided that it was an error not to allow later testimony about the saw, but it was not a reversible error. That is, it would not have changed the outcome of the trial. It was the opinion of the reviewing committee that the theft of a power saw had nothing to do with the flight of the two brothers.

There was other evidence that has been unearthed, which the committee found to be inferential—that is, more circumstantial. For instance, significant stains were found on the clothing of the suspects that were not evaluated. However, the clothing probably came into play too late to be of any value. The committeemen deplored the innuendos, surmises and theories that were repeated until they became accepted as facts. It spent days running down rumors that, by the time the committee heard them, were reported to be probative facts. It cited a terrible misdeed, stating, "A citizen, whose fingerprints were voluntarily submitted to the committee, who, it turned out, had never had any police record, was reported to have been convicted of similar crimes, to have been acquainted with JoAnn Dewey and even to have used her for immoral purposes." That reference was to the unfortunate accusation against Reverend Cranston.

The committee found that it was unable to discover any factual evidence that was favorable to the defendants. On the other hand, it uncovered evidence that the defendants were engaged in illegal activities in a systematic manner. Their statements were contradictory. The official records of the company operating the Playhouse Theater contradicted the alibi evidence given at the trial—that they both told Grant Wilson Monday morning that they had been at a theater in Silverton, Oregon, the night before; prior to March 31, they had never mentioned going to a theater in Portland.

The committee then went on to thank both the defense and the prosecution for their cooperation. It added that it was most impressed with the dignity with which prosecuting attorney R. DeWitt Jones conducted the trial. It saw no reactions to the attempts to inflame passion and prejudice that a less responsible individual might well have felt were justified by the nature of the crime. It complimented the Vancouver Police Department for the methodical and exhaustive investigation.

The governor took a full three weeks to read and reread the report. On January 2, he announced that the investigation by the special committee left no doubt that the defendants had received a fair trial and that they were guilty of the crimes of which they'd been charged.

The *Vancouver Columbian* on January 3, 1953, editorialized:

> *The Wilson brothers now stand convicted of murder. They are no longer entitled to the presumption of innocence. In fact the presumption is now that they are guilty. Neither of them has done anything to overcome that presumption. On the contrary they have, as the committee found, impeded the investigation by their persistent refusal to tell the truth regarding their movements on the night in question. It is my considered opinion that Turman and Utah Wilson are not entitled to clemency or a further stay and that the judgment pursuant to the jury's verdict should now be permitted to take effect.*

Although the Wilsons were sure that last-minute maneuverings would save them, this was the end. Surely, they believed, something would happen. Undoubtedly Goodman and Clements would again find an out. They knew in their hearts that they would not die.

THE EXECUTION

U tah and Turman had a final visit with their parents, Mose and Eunice Wilson, and their brothers Glenn and Grant on Friday morning, December 29, 1952. Afterward, there was a visit with their attorneys, Irvin Goodman and Sanford Clement. They held their composure until the final handclasp by their attorneys. Neither of the men had been told until then that all their legal avenues had at last been exhausted. That day, their writ of habeas corpus had been turned down by two Superior Court judges in Walla Walla. Utah's eyes filled tears. He could not die—he was too young.

Governor Al Langlie invoked an almost forgotten 1903 law that prohibited the press from interviewing Death Row inmates. There were to be no reporters present.

New Year's Day 1953 dawned. It was a Thursday. There had been a full moon shining into their cells the night before. A fresh breeze was blowing. Utah and Turman enjoyed their last meal. They'd ordered roast chicken with giblet gravy, fried rabbit, cranberry sauce, French-fried potatoes, hot biscuits, cherry pie and a devil's food cake with ice cream, milk and coffee. Later, at eleven o'clock, they were moved into an isolation cell, where they were shaved and given new clothing. Turman was dressed in a brown suit, with a white shirt open at the neck. Utah had chosen a blue suit; his shirt was also open at the neck, so as not to interfere with the noose.

Warden John Cranor came to the cell and read the death warrant aloud. More than a dozen witnesses had chosen to attend, including Fred Koch,

Above: The Washington State Penitentiary at Walla Walla, where Utah and Turman met their doom. *Author's collection.*

Opposite: The Marcus Whitman Hotel in Walla Walla, where Irvin Goodman and Sanford Clement stayed when visiting with the Wilson brothers. They checked out for the last time on January 2, 1953. *Author's collection.*

assistant to Governor Langlie; James Pryde, chief of the Washington State Patrol; other law enforcement officials; and newsmen. Their attorneys would not be there.

Irwin Goodman and Sanford Clement checked out of the Marcus Whitman Hotel in Walla Walla at seven o'clock in the evening. Clement said, "There is no point in our remaining any longer, we have no stomach to see it."

"That's all we can do; we're leaving," said Goodman." It's a hard thing to take, but looking back on the case now, I do not believe there was anything we could have done that we didn't do. A man has to live with his conscience.

140

We have lived this case for two and a half years and have devoted almost limitless study and research in preparation for the seventeen or more legal moves we made in defending the Wilsons."

Goodman said that their services for the Wilsons had been pro bono. The brothers had been able to make a token payment for retainers of only about $2,000. "Not enough to cover the phone calls," added Clement. When asked what a fee would have been, he said $50,000 would not have been out of line. "What is a human life worth?" snapped Goodman. They caught a night plane back to Portland.

The warden delivered a telegram to the brothers sent by their brother Rassie from the Oregon State Prison. "May God be with you and bless you," it read. "I love you with all of my heart and am always praying for you. May God bless you until we meet again, Rassie."

Then, at midnight, January 2, 1953, the brothers were led forty feet from the cell to the gallows. There were two gibbets, with trapdoors, separated by a black curtain. The prison used the American military manual specifications for the gallows and the rope. That would be a hemp rope, thirty feet in length, ¾ of an inch to 1¼ inches in diameter; it should be boiled and stretched to prevent recoil. The area of the noose is to be waxed or soaped. The correct hangman's knot of six coils is to be utilized. The hood should be black, with a rough surface on the exterior. It should be split up the back so as to allow it to slide over the prisoner's head smoothly.

The gallows itself was at floor level, with a trapdoor. The witnesses were one floor below behind a glass window. There was a faint odor of chlorine bleach mixed with pine cleaner in the air.

Warden John Cranor and Deputy Warden Al Remboldt were in charge. A chief engineer, standing at the back of the gallows platform, watched for a signal from Remboldt. When it came, he pushed a master button, which turned on a light on the first floor of the death chamber. Four prison employees (not identified), facing four identical buttons, would simultaneously push their button on the light signal. One and only one of the four buttons sprang the electrically generated trap.

The freshly barbered and nattily attired prisoners were guided out onto the gallows floor. Black hoods were placed over their heads, and a noose was put around each man's neck.

Turman appeared calm and said not a word as the trap was released and he fell to his death. Sounds of gasping and moaning were heard by the witnesses, and a trickle of blood ran from beneath the death hood. It was 12:06 a.m., January 3. One minute later, Utah followed. He displayed no

outward emotion. "Everything is Okay, I'm ready," he said. Reverend Morgan Goldberg said, "May God bless you." Utah then fell silently to his death; his body slowly rotated once, counterclockwise. Prison doctors Ralph Keys and Wilmer Unterseher pronounced both men dead sixteen minutes later.

Outrageousness continued. Minutes after the traps sprang open, Western Union called with a telegram. The man read it to Warden Cranor. It was purportedly from U.S. Senator Warren G. Magnuson: "Herewith is ordered a stay of execution of Wilson brothers by emergency decree, presidential authority delegated through me as U.S. Senator from Washington. Confirmation coming from Olympia."

The warden called Senator Magnuson at his home in Washington, D.C. The senator was roused from sleep. He denied sending the telegram. Western Union traced the call to a public telephone in a Seattle tavern. FBI agents identified the hoaxer as a furniture dealer, forty-eight-year-old Thomas E. Thomas. He was arrested and charged with impersonating a federal official. He was sent to federal prison for nine months.

The brothers had asked that their funeral services be held at the Playhouse Movie Theater on Morrison Street in Portland. That was the scene of their alibi. Eunice wanted a church service. The rest of the family urged that the service be held in Portland so that Rassie could attend. They even considered Salem as a venue. The warden of the prison told them that it would not happen. Rassie would not be taken out of prison for the service. It was against the law. Most churches in Vancouver refused to hold the services.

Finally, Eunice agreed. The theater had now closed, and somewhat ironically, the Seventh-day Adventist Church had moved into it. It had soon moved out again, and the Evangelistic Temple had taken it over. The manager felt that arrangements could be made for the service. Public sentiment arose against the idea, and the manager withdrew his offer. At the last minute, the Christian Church in Camas agreed to hold the double service in its chapel.

The Camas sky was dark with ominous, heavy clouds, and then a heavy pouring rain descended on the simple funeral service for the Wilson brothers at the Fern Prairie Church of God. The procession from the Camas Funeral Home was delayed since some of the pallbearers had not been informed of the change of place. More than one hundred people jammed into the church, which had been built for sixty people. Police were on hand at both the church service and the cemetery lest there be trouble, but there was none, except that in the middle of the service, a man stood up and shouted that he had just had a vision in which he saw the real killer of JoAnn Dewey and it was not the Wilson brothers. He was escorted out by the police.

The brothers were in identical gray coffins, surrounded by candlelight. Turman wore a light-gray suit and Utah a dark-blue suit. A heavy scent of gardenias filled the air.

The question haunts Clark County to this day. Were either or both of the Wilson brothers guilty or innocent? The Washington Supreme Court, in its decision of May 10, 1951, called Utah's fingerprint left at the scene within minutes of the crime an "unforgeable signature." That placed him at that spot at that time. Both brothers insisted without fail that they were together every minute of every day from the time of the kidnapping onward. Under the law of felony murder, they were both guilty.

Would they have been found guilty today? With today's forensic science and DNA evidence, it would have been either an inarguable conviction or no charges at all. Had DNA proven the tooth, hair and blood in the Pontiac to be JoAnn's, that would have been the case. There would also have been DNA evidence from the postmortem rape.

Were there others involved? That is a possibility. JoAnn was a strong young woman, and the brothers were undersized men. However, no witnesses ever described more than two men at the scene. They could well have called on someone to help dispose of the body. That person was never suggested, however. The names that Turman used while being recorded in the cell were mostly aliases that he himself used, but they were also living people.

Would they have both been hanged under today's laws? Possible, but doubtful. Felony murder is still the law in the state of Washington. At some point in any violent crime, there is the opportunity to stop.

THE AFTERMATH

No one escapes an event such as this unscathed. Murder is a crime that ripples out and affects more than just the victim and the killer. The circle of pain widens. Family and friends have an emptiness that will never be filled, along with the unanswerable question of "why." Those close to the killers have that same pain, along with many other questions.

To this day, the people of Clark County have formed opinions listening to their parents speak of it. They may not always remember the names or the place, but the murder itself is embedded in the community's psyche. The people directly involved were affected in many ways.

On September 13, 1950, Clark County voters went to the polls for a primary election. The sheriff's race, naturally, attracted the most attention. On the Democratic side, there were six candidates. To no one's surprise, Sheriff Anderson was crushed by Democratic candidate Henry Wentworth. Wentworth had been a King County, Washington deputy sheriff and a captain of the Washington State Patrol. Out of some 15,000 Democratic votes cast, Anderson received just 582. Wentworth, during his campaign, stressed experience, reminding the voters that Anderson had had none.

Clarence McKay, a retired Clark County deputy and the Republican candidate, also stressed his experience in law enforcement. The arrest and conviction of Anderson was never mentioned by either McKay or Wentworth, but it was always there. It would be brought up in letters to the

editor. The conviction and various untruths that Anderson had told during that time were listed in an editorial in the *Columbian* newspaper.

McKay won the election and served for twenty years. Henry Wentworth, the Democratic candidate, sadly, was killed, along with his wife, Paula, in a head-on collision in November 1951, just one year after the election. There is a chapter of the Order of the Eastern Star in Vancouver that is named for him.

The voters rose up against the county commissioners as well, blaming them for appointing Anderson. Clarence Bone and Louis Hall were both shut out in the primary. The coroner, Roy Spady, fell to funeral director Paul Milan, who would face another funeral director, Ronald DuFresne, in November. It was one of the largest turnouts of voters up until that time. All those leading county offices went into the general election with no incumbents, except for prosecutor R. DeWitt Jones, who was unopposed.

Earl Anderson continued to investigate the murder of JoAnn Dewey for the rest of his life. He died in Mountlake Terrace, Snohomish County, Washington, on September 19, 1989.

Clarence R. Bone, the county commissioner who was also a witness to the abduction, was one of the officials voted out of office in the primary election of September 1950. He had been a commissioner for two terms. He did not survive a year after that election, dying at age sixty-seven on July 31, 1951.

Vernice Booth, who had brought the mysterious package of clothing to the defense team, soon divorced her husband. She later married a city worker in the state of Washington and lived peacefully there until her death in 1974.

Reverend Ralph Cranston and his wife, Muriel, left Camas and moved to California. Over the years, he moved from church to church as he was called. He and Muriel retired to Riverside, California, where he died on March 30, 1991.

Collin Cree, who had been at the heart of the incident in Meadow Glade that had precipitated the downfall of Sheriff Anderson, suffered a bizarre death on August 14, 1952, coincidentally the date of that fifth stay of execution for Utah and Turman. He was found slumped over a 6,900-volt California Public Utilities power line that he was attempting to cut with a hunting knife during a severe lightning storm. Cree had become a placer miner in California. It was a forested area. He had been afraid that if lightning should strike a power line, it would set fire to the forest. When the storm began, Cree drove to the power station. He broke in by ripping off a screen and breaking a window. He then broke volt meters, gauges and power equipment. He smashed dials in what appeared to have been frenzy. When

Major General Eugene Cushing commanded the 194th Wolverines in Vancouver Barracks during and after the years he was a Superior Court judge. *Jeff Davis Military History Collection.*

that didn't work, he cut into the main cable. He was found by a nearby resident who'd gone to investigate the loss of power.

Judge Eugene G. Cushing continued a distinguished career. After twenty-one years on the bench in Clark County, he was named United States attorney general for the Western District of Washington State. He was then appointed as pro tem Superior Court judge in King County. At the next election, he ran for the post and was elected for another four years. He had remained in the Army Reserve after the war and retired from the army as a

major general and division commander of the 104th Timberwolves, stationed at Vancouver Barracks. He died just short of his ninety-ninth birthday on August 26, 2004.

Harold Ellis Cusic, Washington state patrolman, a friend and neighbor of the Dewey family, was the brother of Howard Cusic, at whose home the melee involving Sheriff Anderson had occurred and who had filed the complaint. Harold went on to have a stellar career with the patrol. He had joined the state patrol in 1937 but took a military leave of absence when he went into the navy in 1944. He returned to the patrol in 1946. He was promoted to sergeant and became the head of the Chehalis area of the patrol. He quickly became involved in the community, joining the Kiwanis and becoming the coach of Little League. He wrote a regular newspaper column on driving safety for the *Centralia Daily Journal*. He must have had a twinge of déjà vu when, in October 1958, he arrested a deputy prosecutor for drunk driving. The man was a candidate for Cowlitz County prosecutor, and it was just days from election. Cusic was transferred on schedule to the Yakima area in August 1963. He retired from the patrol and lived in Spokane until his death at eighty-five on October 30, 1999.

Anna and Noble Clyde Dewey left Vancouver during the trial. Neither could bear the daily bombardments of reminders of the tragically empty place in their home. They eventually returned to Clark County, to their church and to their neighbors. The children married and began to move away. Ivan, JoAnn's protector, married and moved to the Olympic Peninsula. Another daughter, Ada, died in 1976. Noble Clyde Dewey followed in 1983. A widow, Anna moved north to be with Ivan. She stayed with him until her death in 1994. Both Anna and Clyde are buried at the Brush Prairie Cemetery near JoAnn.

Vancouver chief of police Harry Diamond, while the trial was happening, faced down an armed man who had attempted a robbery at a service station. The attendant responded with tear gas fired from a pencil-type weapon. He then called the state patrol, who notified Vancouver police and Clark County deputies. Harry's men laid a trap. Detectives covered the north end of the bridge, while Harry was at the south end. The officers followed him onto the bridge. Harry got out of his car with his gun drawn to stop the man. The man slowed and stared at the chief. He pulled his gun and leveled it momentarily at Harry. Then he pulled on the emergency brake and shot himself. He died almost instantly.

After the Wilson trial, Harry and Vancouver police would investigate two more murders in the city. James Tabor was convicted of killing his wife,

Harry Diamond, in retirement, shares his stories of his term as the longest-serving chief of the Vancouver police. *Author's collection.*

and Donald Pribbernow was convicted of murdering a church volunteer, Hulda Trautman. Harry retired in April 1962 after twenty-seven years in the department. Seventeen of those years were as chief, the longest-serving in the department's history. After his retirement, he was appointed as a chief deputy U.S. marshal. When he resigned from that position, he and his wife, Bertha, traveled and raised flowers in their Fruit Valley neighborhood home. He died on July 22, 1996, at the Washington Masonic Home at the age of eighty-eight. His wife and son had predeceased him. Diamond Park, off Forty-Eighth Avenue near Thirty-Fourth Street in Vancouver, is named for the chief.

Russell Duke, the man with the inside information on the Dewey case and the records of Reverend Cranston, would be called before a Senate committee investigating tax fraud and influence peddling. He was accused of perjury before that body, but the case was dismissed as all the testimony was based on his own words to the committee. The final report noted, "It is quite clear that Russell W. Duke was an influence peddler who specialized in tax cases." In the absence of any legal accounting or other technical ability, he used his alleged influence with his alleged contacts. There is no evidence

that he performed any legitimate service to any taxpayer. There is also no evidence that he has told the truth on any matter.

Irvin Goodman never lost another murder trial. His next headline-grabbing case was the April 1953 Smith Act trial in Seattle. Six people were charged, as Communists, with conspiracy to overthrow the government. Irvin was on the defense team. He argued via the First Amendment that they had the right to teach and advocate. During his argument, he objected to the prosecution referring to itself as the government. He was widely quoted for saying, "The prosecution does not represent the government any more than an umpire in a baseball game represents one team against the other." He died on June 30, 1958, of heart disease complicated by surgery, just over five years after the Wilsons' execution.

R. DeWitt Jones continued to be reelected until he resigned his position in 1969 as the longest-serving prosecutor in Clark County history, with thirty-four years of service. He continued his private law practice, averaging half pro bono work. His wife, Helene, said of him, "He could have been a rich man, but he always wanted to help someone." His daughter, Emilou, fondly remembered him once bringing home eggs; he said that that was all his client could afford to pay. Golf was his other passion, and he was a longtime member and advocate at the Royal Oaks Country Club. He hit a hole in one on Thanksgiving Day 1952, following a family tradition—his father, his brother and a brother-in-law had already secured that achievement. His files were full of thank-you letters that he unfailingly wrote to anyone who assisted on a case. He fell in 1993, and X-rays showed a cancer on his spine. He was taken to a care facility, where he died just a week later on December 2, 1993. He had asked that in lieu of a funeral, his friends get together at the cocktail lounge Inn at the Quay. This was done. His final wish was that after cremation, his ashes should be put in a plane and half scattered over the county courthouse, with the rest flown up the Columbia River and scattered over the town of Stevenson, where he had grown up.

Deputy Sheriff Cletis Edward Luse, a friend of Utah and Lucille Wilson's, left the Sheriff's Department with Sheriff Anderson. He would live on in Vancouver with his wife, Adah, and their son, George. He died on December 8, 1986. He'd kept the investigator's notebook of the Dewey case for the rest of his life. His grandson, Douglas Luse, would find the notebook while clearing out the house after his death. Douglas had continued the law enforcement tradition by joining the Vancouver Police Department on January 5, 1987.

Irvin Goodman had made his reputation as a radical lawyer. He was eager to take on the unpopular causes. In this photograph, he is standing with his co-counsel to his right, Tracy Griffin, and accused Soviet spy Nicolai Redin. *Author's collection.*

Terry Schrunk was one of Multnomah County's most colorful and controversial sheriffs. He would go on to be elected Portland's most colorful and controversial mayor in 1957. He beat the incumbent mayor, Fred Peterson, in the primary, but not by enough to be elected. He did win, however, in the general election by a large majority. He served as mayor of that city until 1973.

Donald Strawn, the deacon whose affair with JoAnn had sent the investigation off into a series of dead-ends, was a World War II navy veteran. He had been injured when his ship was torpedoed during the Battle of the

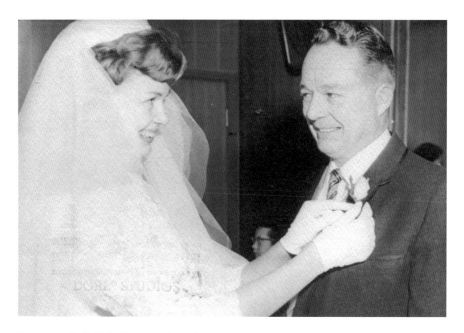

Prosecutor R. DeWitt Jones receives a boutonniere from his daughter, Emilou. When the case went to the jury, he turned the trial over to his assistant, Don Blair, to take time away with his family. *Emilou Jones Nelson Collection.*

Solomons. That would cause physical problems later in his life. He and his wife, Noralee, divorced soon after the case was resolved. Their marriage had been troubled for some time; they had filed for divorce once, in 1949, but had patched it up. Later, he had a few marriages; there were some money problems, an arrest for nonsupport, a suit for a loan recovery and a traffic accident. In the end, he lived a peaceful life, dying quietly in Monsanto at eighty-eight years.

Eunice Wilson never stopped protesting the innocence of all of her sons. "All of my boys are good boys," she would say. "They just got into bad company." She brought her sons home after their deaths and had them buried together. Only Grant outlived her. She died in October 1986.

Glenn Thurman Wilson, after his release from prison, moved to Florence, Oregon. He was arrested in Reno, Nevada, on April 25, 1953, carrying two pistols. He was arrested on a charge of carrying a concealed weapon. Wilson was transferred to justice court, when it was learned he was an ex-convict in possession of a firearm. Wilson said he'd gotten a tip in Salt Lake City that if he came to Reno and "saw the right people he could solve the murder for which his brothers had been executed,"

Throughout the trial and appeals, the forgotten person was the victim, JoAnn Louise Dewey, who never celebrated her nineteenth birthday. *Author's collection.*

according to the *Nevada State Journal*. He later moved to Florida. There, he was caught during a burglary. To escape, he ran and leaped over a fence, breaking his neck and dying there. His first instinct had always been to run. In the end, it caused his death.

Grant Wilson struggled with guilt, according to friends. He lived out the rest of his life in Camas. He cared for his mother, Eunice, and paid for her grave site next to his brothers. He died at the age of eighty-seven in 2015.

Lucille Cline Wilson made her way after the trial and divorce by teaching dancing. She was always a petite woman, and her family said, "She had legs as pretty as Betty Grable's." It was difficult for her to find stability, however. She moved from state to state and from marriage to marriage. She would marry six more times before dying in August 2006 at the age of seventy-three. She was, in a way, yet another victim of the Wilson brothers.

Mose Wilson moved into Vancouver. Ironically, he was the victim of an armed robbery in June 1955, when two armed men forced three employees, Mose among them, into a cooler at the Valley Farms Market. The bandits escaped in a light-green pickup that they had stolen from one of the victims. When Mose died in 1964, Eunice brought him back to Camas to be buried with their sons.

Rassie Wilson, still suffering from tuberculosis, would be freed only when his sentence was fulfilled. He married in August 1961 and moved to

Lewiston, Idaho. He was pardoned on humanitarian grounds by Governor Tom McCall in 1975 and died from the disease in 1989. His body was brought back by his mother, Eunice, and buried at Camas Cemetery next to his brothers.

Murder is a crime without a statute of limitations. It has been called the "ultimate theft." What is stolen is that most precious belonging: life. It is an act that cannot be undone, the loss unrecoverable. Life has been stolen not only from the victim but also from family, friends and the future. Ultimately, life was taken from the killers and their family as well.

BIBLIOGRAPHY

Bend Bulletin. August 14, 1952.

Clark County Sun. Numerous dates between April 20, 1950, and June 26, 1950.

Corvallis Gazette Times. April 19, 1949; October 31, 1951.

Daily Capitol Journal. August 13, 1952.

Department of the Army. *Procedure for Military Executions Department of the Army 9 December 1947.* Pamphlet 27, no. 4. The Army Library, Washington, D.C.

Eugene Guardian. January 14, 1950.

Farrell, William, CCSO, Vancouver Police Department (retired). Interview, May 2004.

Grafton, Richard. "Vancouver Police Officers: The Good, the Bad, the Indifferent, 1855–2004." Unpublished manuscript.

History Link Washington. Timeline. www.historylink.org/File/9573.

LaGrange Observer. March 31, 1950.

Luse, Sergeant Cletis. "JoAnn Dewey Kidnap and Murder, Case #19." Investigator's Notebook, Clark County Sheriff's Office.

McKay, David. *Clark County History Annual.* The Office of the Sheriff, Clark County Washington. Published by the Clark County Historical Society, 1993.

Medford Mail Tribune. June 16, 1950; November 8, 1950.

Nevada State Journal. April 28, 1952.

Oregon Democrat Herald. September 21, 1951.

Oregon Journal. August 13, 1952; January 4, 1953.

Portland Oregonian. Numerous dates.

(Roseburg, OR) News Review. June 15, 1950; August 14, 1952; August 16, 1952; July 1, 1958.

Sharpe, Franklin. "The Bizarre Case of Washington's JoAnn Dewey." *Official Detective Stories* (June 1950): 2–7, 50–52.

Statesman Journal. November 21, 1942, through December 12, 1942; March 30, 1950; December 9, 1951; December 12, 1951.

Vancouver Columbian. Numerous dates between March 19, 1950, and January 7–8, 1953.

Vancouver Police Department Scrapbook. JoAnn Dewey Case. Collected clippings from local newspapers.

Vancouver Tribune. June 19, 1950.

Walla Walla Union Bulletin. December 10, 1952.

Washington State Archives. Report to Governor A. Langlie, n.d.

INDEX

ABOUT THE AUTHOR

Pat Jollota came to Vancouver, Washington, in 1982 from Los Angeles, where she had spent twenty-two years as a civilian employee of the Los Angeles Police Department. Her late husband was a sergeant in that department. She became a curator at the U.S. Grant Museum shortly after her arrival and then curator of education at the Clark County Historical Museum. She remained in that position for twenty years.

Meanwhile, she was elected to the Vancouver City Council and served on that body for twenty years. While there, she was appointed by the National League of Cities to serve on its steering committee for Public Safety and Crime Prevention. She was one of the founders of the Children's Justice Center in Clark County and remains on its board, as well as that of the Elder Justice Center. She was named a First Citizen of Clark County in 2012.

She has published two books for the Clark County Historical Society, as well as four volumes for Arcadia Publishing.